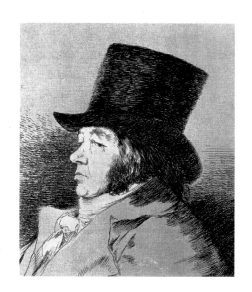

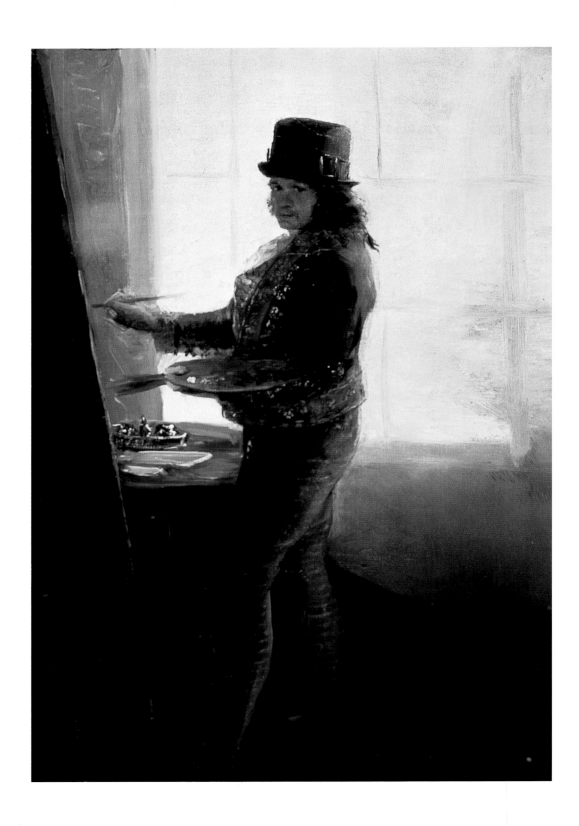

Rose-Marie and Rainer Hagen

FRANCISCO GOYA

1746–1828

TASCHEN

KÖLN LONDON LOS ANGELES MADRID PARIS TOKYO

COVER:
Maja Clothed (detail), 1800–1805
Oil on canvas, 95 x 190 cm
Madrid, Museo del Prado

BACK COVER:
Self-portrait in the Workshop (detail), 1790–1795
Oil on canvas, 42 x 28 cm
Madrid, Museo de la Real Academia de San Fernando

ILLUSTRATION PAGE 1:
Self-portrait (frontispiece of *Los Caprichos*), 1797–1798
Etching and aquatint, 21.9 x 15.2 cm

ILLUSTRATION PAGE 2:
Self-portrait in the Workshop, 1790–1795
Oil on canvas, 42 x 28 cm
Madrid, Museo de la Real Academia de San Fernando

© 2003 TASCHEN GmbH
Hohenzollernring 53, D–50672 Köln
www.taschen.com
Coordination: Christine Fellhauer, Cologne
Layout: Catinka Keul, Cologne
English translation: Karen Williams, Whitley Chapel
Cover design: Catinka Keul, Angelika Taschen, Cologne

Printed in Germany
ISBN 3–8228–1823–2

Contents

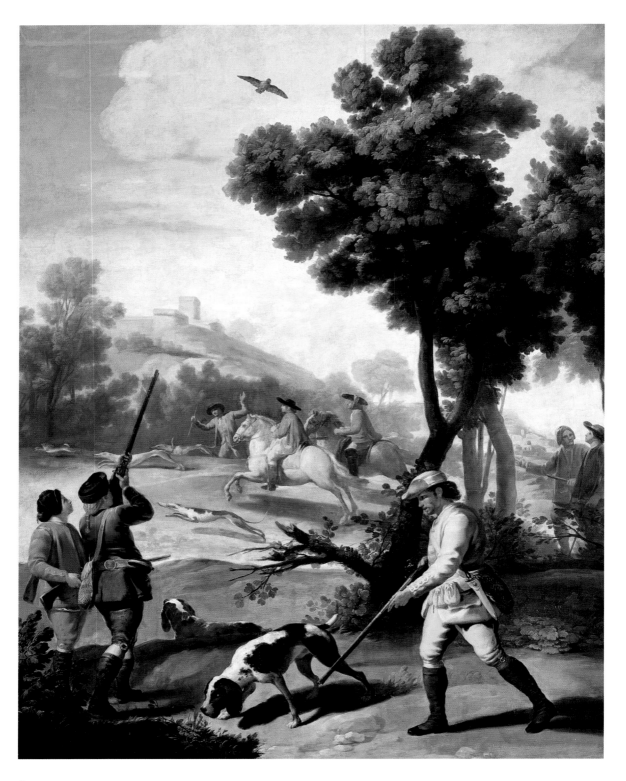

Cheerful Scenes for Gloomy Palaces – The Tapestry Cartoons

In 1774 Francisco Goya moved to Madrid. He had been commissioned to design tapestries for the Royal Tapestry Factory of Santa Bárbara. His age: 28. He had grown up in the provinces, in Saragossa, where he trained under local artists. He had secured the tapestry commission not because of his striking talent, but through family connections. He had got married the year before and his brother-in-law, a well-regarded painter in Madrid, arranged the job for him.

Twice already Goya had tried to gain a foothold in Madrid, submitting paintings to the Royal Academy of Fine Arts of San Fernando in the hope of being able to study there. On both occasions, in vain. He had then gone to Italy, where he received a special mention in a competition at the Parma Academy. Back in Saragossa, he was commissioned to execute a number of frescos in churches. But it was to Madrid that he longed to go; with its 150,000 inhabitants, it was the largest city in Spain, the seat of government, the residence of the royal family – and home to the Royal Academy. Since public museums and galleries did not exist, the Academy was the best way of making a name for oneself outside the provinces. Goya would later become a professor at the Academy, and even its director. But when he needed it, its doors remained shut.

Designing tapestries was not a highly regarded task, nor was it well paid, but it offered the young artist a start in the big city. And the commissions came directly from the Court. Five years later Goya would be presenting his designs to the King and the Crown Prince and Princess in person and thereby kissing their majesties' hands. A great occasion for a man eager to rise to the top. The tapestries were required for San Lorenzo del Escorial and the Pardo, two palaces outside the city in which the royal household spent several of the autumn and winter months. Wall-hangings offered protection against the cold and damp and brought life into the largely gloomy rooms. In the past, such tapestries had been obtained from the Netherlandish provinces, but these no longer formed part of the Spanish Empire. Hence the need for a royal tapestry factory in Madrid.

It was the artist's task first to produce designs and then, once these had been approved by the Court, to transfer them to cartoons, i. e. canvases in the format of the tapestries to be woven. Tapestries traditionally took their subjects from Greek mythology or the history of Rome, but Goya and other young artists were to offer something new – scenes not from the past, but from present-day Spain. Goya's first set of cartoons was executed for the Prince of Asturia, the later King

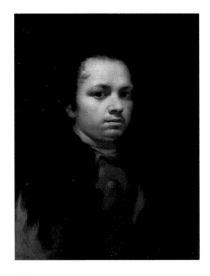

Self-portrait, 1771–1775
Oil on canvas, 58 x 44 cm
Madrid, Collection Marquesa de Zurgena

An ambitious young man at the start of his career. He comes from the provinces, from humble circumstances, and is looking for commissions.

ILLUSTRATION PAGE 6:
The Quail Shoot, 1775
Oil on canvas, 290 x 226 cm
Madrid, Museo del Prado

The commission to design tapestries for the royal palaces at last enabled Goya to move to the capital, Madrid. The first series of tapestry cartoons shows hunting scenes, tailored to the interests of the heir to the throne, the later Charles IV.

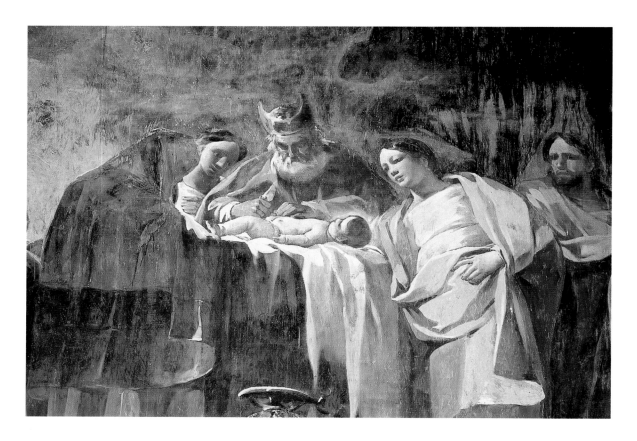

Charles IV. This prince was interested in only one thing: hunting. So Goya de-
signed hunting scenes. The heir to the throne was married to María Luisa of
Parma, who wanted her tapestries to show popular diversions, in other words
ordinary people enjoying the pleasurable pursuits in which she, the tempera-
mental Italian princess, was not permitted to indulge at the strict Spanish court.
María Luisa's desire to surround herself with light-hearted scenes from everyday
life also followed a trend being acted out in the theatres of Madrid: between the
acts of classical dramas, the public would be entertained with comic scenes from
the daily lives of the lower classes.

Unlike the religious motifs of his Saragossa work and his hunting scenes
for the Crown Prince, these cartoons of "popular diversions" now gave Goya an
opportunity to show how people behaved and how they treated each other. It
is a theme that he here expounds humorously and light-heartedly, but which
would later present itself to him in a completely different light. From this early
period stems the only self-portrait in which Goya is looking neither sceptical
nor gloomy: a broad, flat face with high cheek-bones, not actually called a self-
portrait but undoubtedly Goya (ill. p. 9). He is standing with a number of other
young men near a bull, evidently at a *novillada*, a bloodless fight with young
bulls. Goya himself is reported to have engaged in such risk-laden pursuits –
or perhaps that was just a rumour he spread himself. It would not be out of
character: bullfighting fascinated him right up to the end of his life. He signed
one of his letters Francisco de los Toros – "Francisco of the bulls".

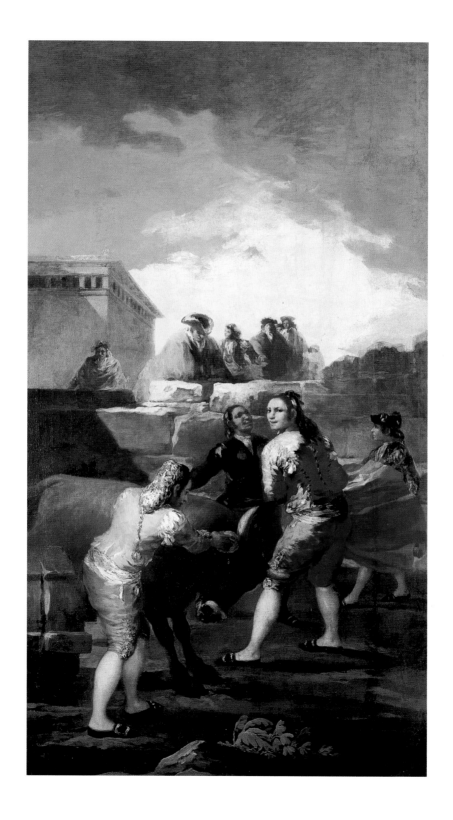

The artist was familiar not only with bulls, but also with *majos* and *majas*, men and women from the "lower quarters" of Madrid with a particular style of dress and conduct. They emerged in the 18th century, and in *A Walk in Andulusia* (ill. p. 11) Goya points to their origins, the gypsy communities in the south of Spain. Typical of the clothing worn by the men is the *capa*, the wide cape, and a hat pulled down far over the face. Since it was easy to hide oneself beneath them, in 1766 both the hat and the *capa* were banned in Madrid. The ban (in conjunction with other government measures) provoked an uprising and had to be revoked.

The typical *majo* was proud, easily offended and quick to pull a knife. He relished his eye-catching costume and, as far as he could help it, never worked. This reluctance to do any type of work at all, widespread amongst Spanish men in the 18th century, dated back to the time when Columbus discovered America. The new colonies sent their gold back to the king, who gave it to his favourites and his far too many officials and officers. Although this "Golden Age" was long gone, the pretension to idleness had remained, even amongst those classes who had never directly profited from the king's gold.

The female pendant to the *majo* was the *maja*, a woman with a passionate nature who took a delight in being provocative. She had to have a ready supply

ILLUSTRATION PAGE 11:
A Walk in Andalusia, 1777
Oil on canvas, 275 x 190 cm
Madrid, Museo del Prado

The popular dress worn by *majos* and *majas* was thought to have originated amongst the gypsies of southern Spain. Adopted by the people of Madrid at first for May Day festivities, in the 18th century it became a sort of national costume and a form of protest, too, against French influence.

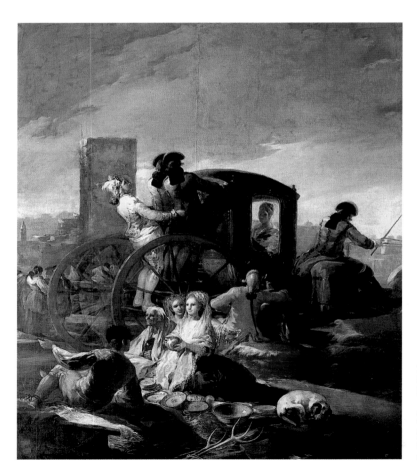

The Crockery Vendor, c. 1779
Oil on canvas, 259 x 220 cm
Madrid, Museo del Prado

A smart carriage rolls across the marketplace. The men only have eyes for the lady seated inside. Two young women, supervised by an ugly old woman, show off their own charms as they examine the crockery on display.

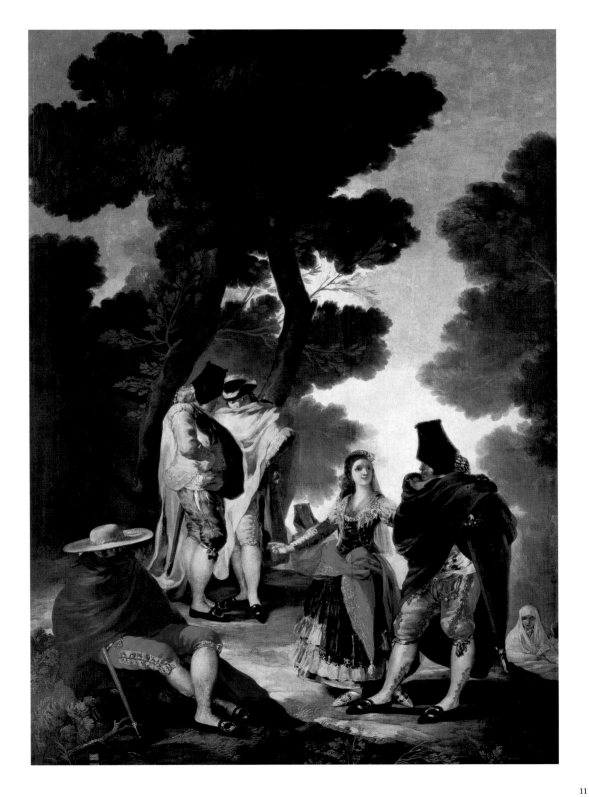

of cheeky answers, had to be *salada*, salty. She earned her living selling oranges and chestnuts or as a maid in an aristocratic household. She worked hard, since she usually also had to feed and clothe her *majo*. Both *majo* and *maja* wore their hair in a net; the women dressed in clothes that emphasized their figures, usually brightly coloured and revealing a plunging neckline and foot and ankle. In Goya's day their fashions were imitated in the upper echelons of society and became a sort of national costume, offering a contrast to the Parisian fashions which otherwise dictated the style. They offered an elegant, playful form of protest against French domination. Spain had been ruled by descendants of the French house of Bourbon since 1700, and in their running of economic and administrative affairs, in particular, the Spanish kings had oriented themselves towards their French forebears. Their tolerance of some of the heretical ideas of the Enlightenment thereby displeased the conservative element of the Spanish population.

Several of Goya's cartoons portray the French and Spanish fashions next to each other. Seated on the ground in *The Parasol*, for example, is a wealthy young woman dressed in the French style (ill. p. 12). She is taking a rest, we might imagine, while out for a stroll; a little dog is recovering in her lap. Her face is shaded from the sun by a parasol, held by a young man who, in *majo* style, wears his hair in a net and a colourful silk sash as a belt. Whether he represents a servant or a *cortejo*, a male companion of the same social rank as the married women he was permitted to escort, remains unclear. The woman herself is young; women were thought to be at the height of their beauty at 15 or 16

The Parasol, 1776–1778
Oil on canvas, 104 x 152 cm
Madrid, Museo del Prado

María Luisa, Charles's wife, wanted cheerful scenes for the tapestries in her dining room. Goya responded with this picture of an elegant young lady with a lapdog beneath a green parasol.

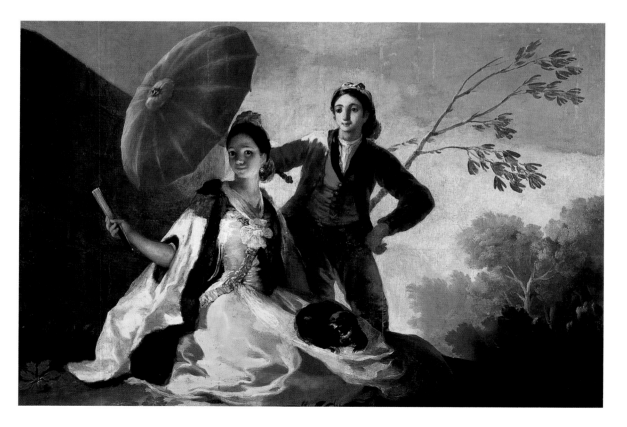

Blindman's Buff, 1788–1789
Oil on canvas, 269 x 350 cm
Madrid, Museo del Prado

A game as a form of courtly entertainment: gathered on
the banks of the Manzanares river are a number of
ladies and gentlemen, some dressed in the latest Parisian
fashions, others in the flamboyant costumes worn
by Spanish *majos* and *majas*.

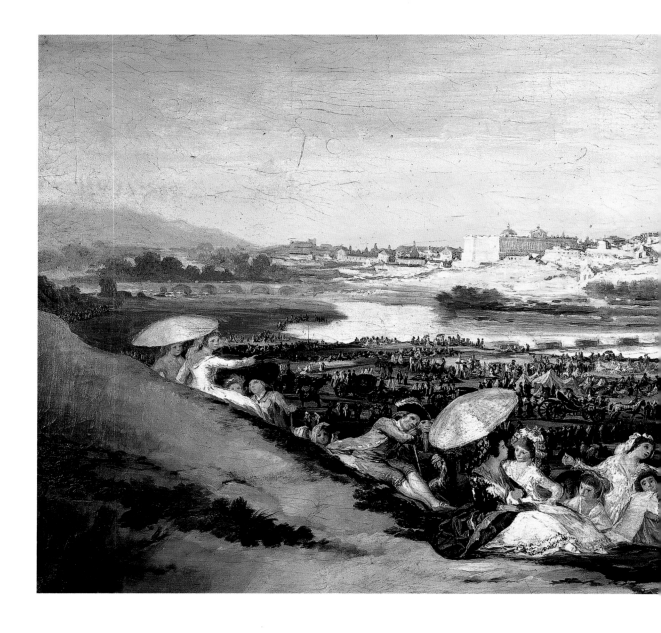

The Meadow of St Isidore, 1788
Oil sketch on canvas, 44 x 94 cm
Madrid, Museo del Prado

Goya here invites the viewer to a join a picnic
on the feast day of St Isidore, patron saint of
Madrid. Set against a panorama of the city,
the scene was designed for the bedroom of
the young daughters of the Crown Prince.
No tapestry was ever woven from the painting,
which progressed no further than this almost
Impressionistic sketch.

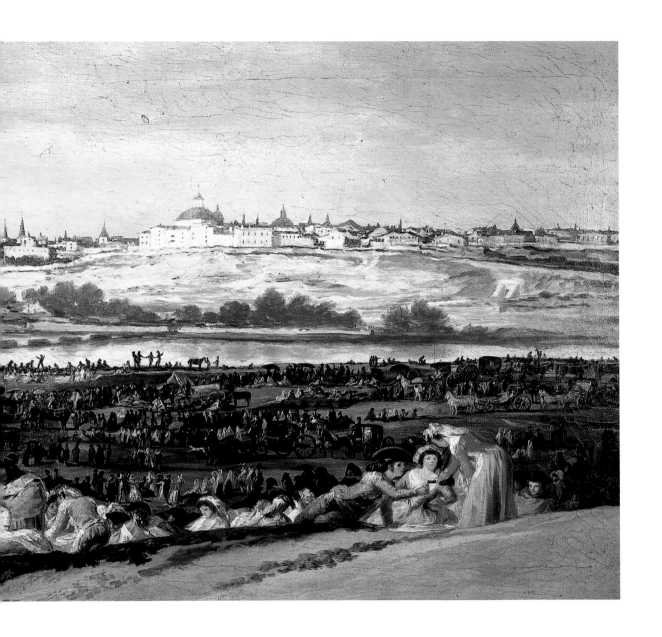

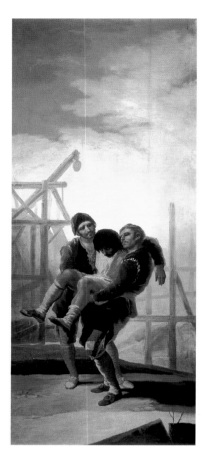

The Injured Mason, 1786–1787
Oil on canvas, 268 x 110 cm
Madrid, Museo del Prado

In place of games and picnics, Goya here offers the Spanish court a more realistic insight into the lives of the lower classes. A labourer has fallen off some scaffolding and is being carried away by two colleagues, their clothes shabby and torn.

and were married at this age. The young lady in Goya's canvas clearly knows how to strike an eye-catching pose, and even though she is not wearing the costume of a *maja*, she seems to have all the latter's self-assurance. Her lovely eyes appear to scrutinize the viewer with a certain coolness. Goya also portrayed both the Duchess of Alba and Queen María Luisa in *maja* costume, and in one tapestry he shows representatives of both fashions hand in hand playing a game of *Blind-man's Buff*, some in hats and wigs, the others with their hair in a net (ill. p. 13).

Another of Goya's scenes of "popular diversions" is *The Meadow of St Isidore* (ill. p. 14/15). The design dates from 1788 and thus arose 14 years after he had first started work for the Santa Bárbara Royal Tapestry Factory. The feast of St Isidore, patron saint of Madrid, is celebrated on May 15 every year. In the morning, after mass, the people of Madrid walk in precession behind priests and a brass band across the river to the saint's hermitage, where they celebrate High Mass, drink from the holy spring and call upon Isidore to answer their prayers. Then they deposit themselves in the fields along the banks of the Manzanares river, eat, dance and play games. Goya combines the merry picnic with a panorama of Madrid, whereby he gives particular prominence to two new buildings: on the left the massive block of the royal palace on the former site of the Alcázar, destroyed by fire, and further right the domed church of San Francisco el Grande, for which Goya had painted an altarpiece. He was by now much in demand as an artist and even had his own carriage. As a specialist in carriages, he depicts a large number of them parked in several rows along the bank of the Manzanares at the bottom of the painting. Carriages were a status symbol; those who owned one no longer belonged to the class of *gente de a pie* – people who went on foot. Goya acquired his first carriage in 1786, two years prior to painting the feast of St Isidore. In a letter to a friend, he described how, on a test drive, "the owner and I drove very grandly" through the streets of Madrid, but once outside the city broke into a furious pace. The owner asked Goya if he would like to learn how to do a "Neapolitan turn". Goya handed him the reins and immediately found himself "turning somersaults in the air" with the horse and carriage. This letter is one of the rare written documents shedding light on the artist's personal life, a letter full of pride and high spirits and self-irony. It characterizes Goya in a phase that would not last long. Goya adds that he has now organized his life enviably and is being showered with commissions for portraits. He holds the title of Painter to the King and has also become a member of the Academy.

In *The Meadow of St Isidore* Goya mixes classes and fashions, but avoids brawling and erotic allusions as being unsuited to the commission – the tapestry was intended for the bedroom of two young princesses. It was never woven, however; all that survives is an oil sketch measuring 44 x 94 cm, almost Impressionistic in its manner. One of the reasons why the design was taken no further may have been its wealth of small detail. Thus the weaving masters complained that Goya was no longer taking sufficient account of the technical limitations of their art. Goya himself probably lost interest in producing paintings that were never valued for themselves but remained only the means to an end.

Nor did he want to restrict himself any longer to pleasurable subjects alone. In 1786 he executed cartoons of the four seasons and concluded the cycle with a design clearly affirming how harsh life in winter is for the rural population (ill. p. 17). That same year he painted a drunken labourer being carried off by two colleagues (ill. p. 16). Drunkenness was considered dishonourable in Spain and had no place in a royal palace. Goya must have known this and subsequently changed the drunken man into an injured one. Although pain and suffering

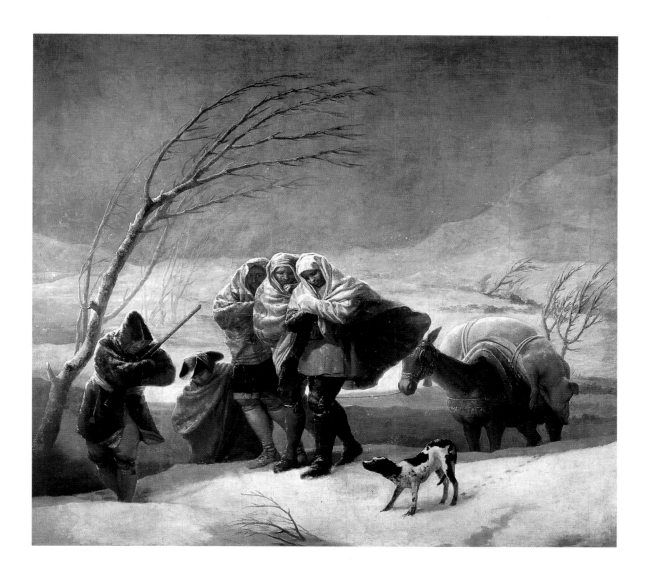

Winter/The Snowstorm, 1786–1787
Oil on canvas, 275 x 293 cm
Madrid, Museo del Prado

From the middle of the 1780s, the successful
artist no longer confined himself to the
portrayal of pleasurable pursuits. He shows
how harsh winter can be for Spain's peasants.

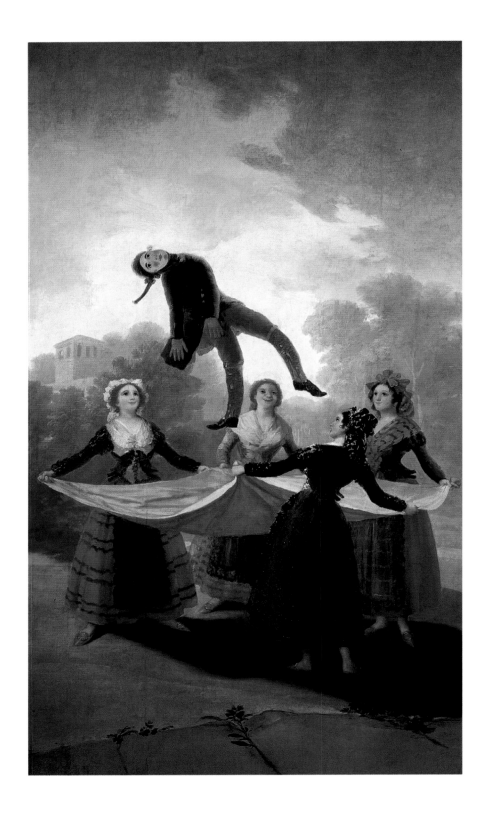

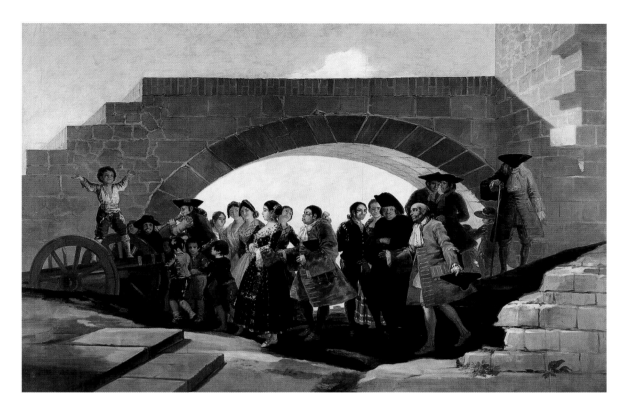

normally fell outside the subjects preferred by the royal family, the King had issued a decree whereby the families of injured labourers were to receive aid. Thus the accident in Goya's painting could be seen as bolstering the King's image as a welfare provider.

Amongst the last of Goya's 62 cartoons are *The Wedding* (ill. p. 19) and *The Straw Mannequin* (ill. p. 18) which again reflect the desire for scenes of "popular diversions", but whose mood is no longer as cheerful as in earlier years. *The Wedding* contains a criticism of marriages concluded solely for the sake of money. The beautiful bride, her head held proud, is followed by a groom with ape-like features and a hunched build. He may be richly dressed, but when it comes to looks he is no match for his wife. In Spain, as elsewhere in Europe, such ill-matched marriages were a popular subject of comedy and caricature. There is satire, too, in the game being played in *The Straw Mannequin*, in which four young women are tossing a male doll up into the air – a carnival custom which demonstrates that women are able to do with men whatever they like. In two designs Goya depicts the doll with its head raised, as if enjoying the sensation of flying through the air. Only in the cartoon is the head sagging; the mannequin as helpless victim. The artist portrays the tossing of the doll as a symbolically cruel game. Here man is seen at the mercy of feminine wiles, just as Goya's later pictures will regularly feature male violence against women. How people treat each other is something Goya, in his tapestry cartoons, illustrates in bright colours, as his royal patrons wished it. His cheerful palette probably also reflects the optimism of an artist successfully rising through the ranks. Later, a few years older and freed from obligations to his employer, he would see people differently.

The Wedding, 1791–1792
Oil on canvas, 267 x 293 cm
Madrid, Museo del Prado

In his later tapestry designs, Goya shows himself unafraid to introduce satire and criticism of the society of the day. With the blessing of their families and the Church, an ugly, rich groom is marrying a pretty young bride.

ILLUSTRATION PAGE 18:
The Straw Mannequin, 1791–1792
Oil on canvas, 267 x 160 cm
Madrid, Museo del Prado

The artist's gaze grows ever more critical. A light-hearted carnival tradition here assumes a cruel dimension in a scene that shows what strong women can do with a weak man.

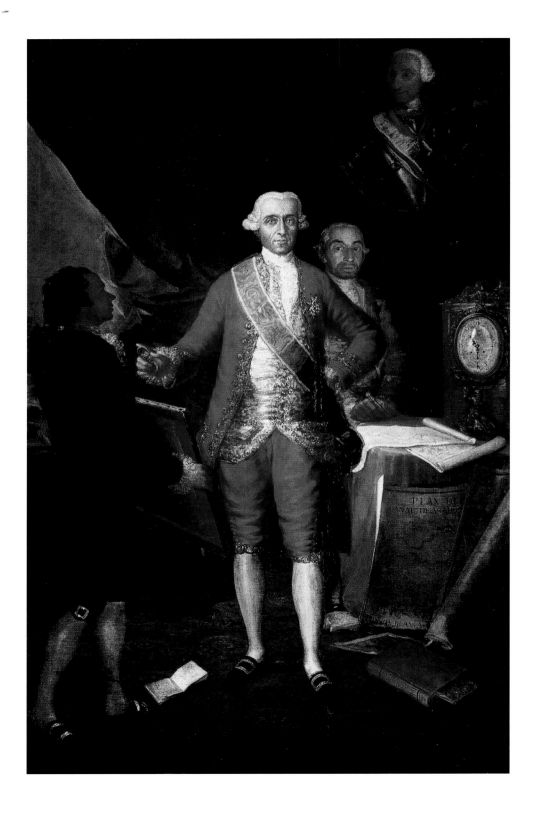

People of Yesterday – The Portraits

If Goya established a foothold in Madrid with his tapestry cartoons, it was with his portraits that he rose to fame. His ascent is officially documented by the successive titles conferred upon him: in 1786 Painter to the King, in 1789 Court Painter and in 1799 First Court Painter. The grander the title, the more generous the salary that went with it.

As public recognition for his work grew, so too did Goya's self-confidence, as can be seen in a comparison of two self-portraits. Neither is a work in its own right; rather, the artist in both cases appears as a subsidiary figure in canvases dedicated to high-ranking dignitaries. The first is the Portrait of *The Count of Florida-blanca*, a royal minister. The artist, hovering humbly on the edge of the painting, is holding up an unframed picture for Floridablanca's approval. His face is visible only in *profil perdu* as he looks up at the powerful Count. A painting of 1783.

Very different, on the other hand, is a self-portrait of 1800. In *The Family of Charles IV* (ill. p. 28), Goya is again standing at the edge of the assembled company, but this time has his eyes turned to the front like everyone else, shows his face, and has drawn himself up to his full height as if he is as much a part of the group as anyone. He has thereby oriented himself towards Velázquez' *Las Meninas*, a painting executed some 150 years earlier, which also portrays members of the royal family and in which Velázquez includes himself standing at the easel. In the 18th century Velázquez was admired as the greatest Spanish painter of them all; Goya had studied his works in the royal collections, making copies of a number of them (ill. p. 29). The fact that Goya includes himself in a royal portrait, in exactly the same way as his famous predecessor, shows how his opinion of himself has grown.

His increasing self-confidence and his contact with members of the ruling class and the nobility changed Goya's thinking. In 1790 he wrote to a friend that he had taken it into his head "to preserve a certain dignity which a man ought to possess". Amongst other things, this meant no longer going to places where there was public dancing and where he might hear the popular *seguédilla*, for example. Or rather it "most probably" did, as he added by way of modification, admitting that "all of this does not make me very happy". Not very happy, because he was trying to – or having to – disassociate himself from the milieu in which he felt at home. *Majos* and *majas*, bullfighters and orange-sellers now had to give way to the behavioural code, language, ideas and value systems of the powerful.

The Count of Floridablanca (detail), 1783
Oil on canvas, 262 x 166 cm
Madrid, Banco Urquijo

The Count of Floridablanca, 1783
Oil on canvas, 262 x 166 cm
Madrid, Banco Urquijo

Goya's first formal portrait of an important politician, Charles III's first minister for many years, amidst the attributes of his office. Goya used the portrait to publicize his talent and includes himself on the edge of the composition in a subservient pose.

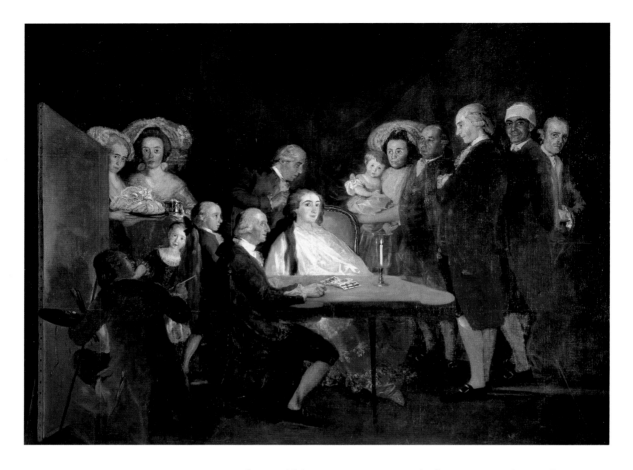

***The Family of the Infante Don Luis**, 1783*
Oil on canvas, 248 x 330 cm
Parma, Mamiano di Traversetolo, Fondazione
Magnani-Rocca

The brother of King Charles III – banished
from court for marrying beneath him – com-
missioned this group portrait of his family and
servants. It is evening; the master of the house-
hold is playing cards, while his wife is having
her hair done.

ILLUSTRATION PAGE 23:
***The Family of the Duke of Osuna**, c. 1788*
Oil on canvas, 225 x 174 cm
Madrid, Museo del Prado

This "enlightened" couple, members of the
upper aristocracy, were amongst the artist's
most influential patrons. Pomp and status
symbols are renounced in favour of a discreet
idyll in a subdued palette of greys, browns and
greens.

Their world, however, was in a state of collapse. In Paris, the Bastille was
stormed. France's aristocracy lost its privileges and the Church its possessions.
The new National Assembly called for liberty, equality and fraternity. Over 1000
French nobles were sent to the guillotine, the King and Queen amongst them –
the King a cousin of the Spanish monarch. Napoleon rose to power, set his
armies upon his neighbours and occupied half of Europe, including Spain, only
to be defeated and sent into exile, leaving the former ruling dynasties to return to
their thrones. All this between 1789 and 1814, a quarter of a century which Goya
spent in Madrid, executing the portraits of whoever happened to be in power.

The Count of Floridablanca (ill. p. 20) was the first of the senior members
of the aristocracy he was invited to paint. Goya portrays him as a representative
of the old order, the *ancien régime*, with a wig and lace jabot. The sash across his
chest acknowledges his services to his king, Charles III, who looks graciously
down upon him from a portrait on the wall. The red of Floridablanca's clothes
dominates the palette. As usual in conventional portraiture, a heavy curtain de-
limits the background. Goya uses all the artistic means he knows of establishing
the sitter as an important and high-ranking personality.

Quite different his portrait of Minister of Justice *Gaspar Melchor de Jovella-
nos*, painted 15 years later in 1798 (ill. p. 25). It is true that the artist again makes
use of a background curtain, but the minister is now plainly dressed, without

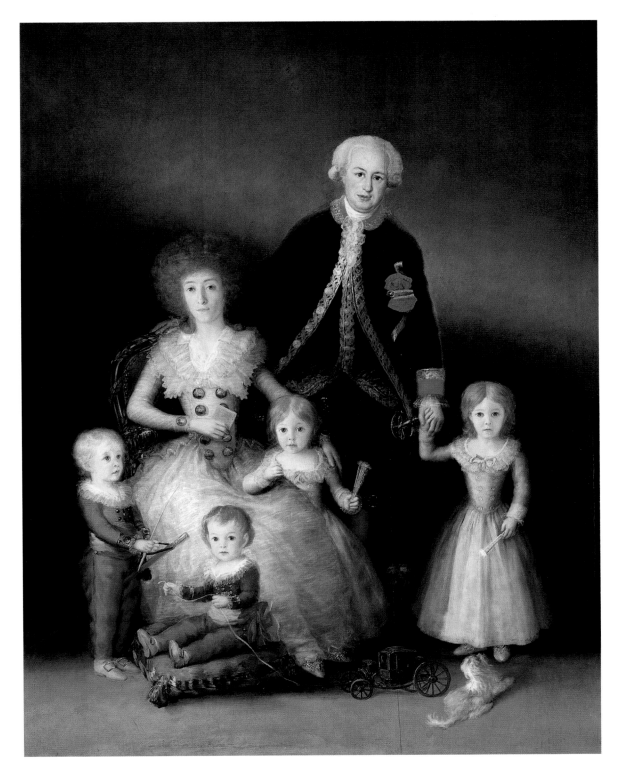

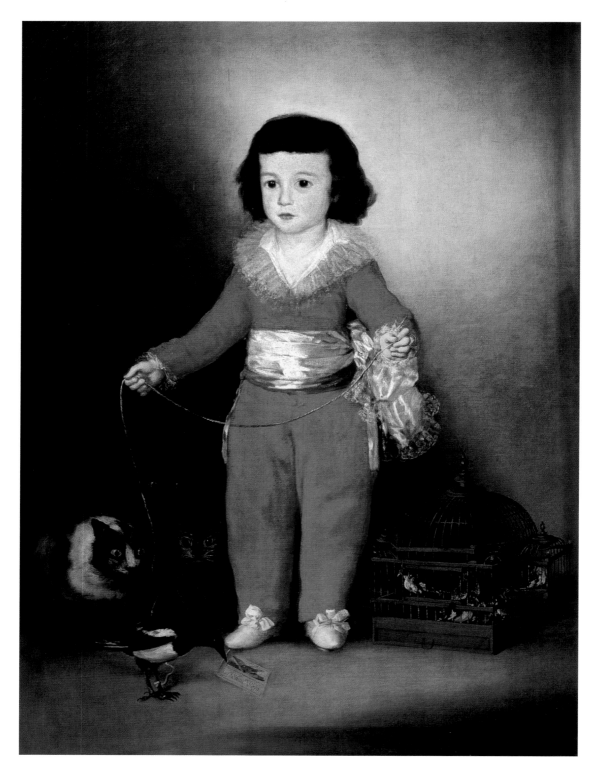

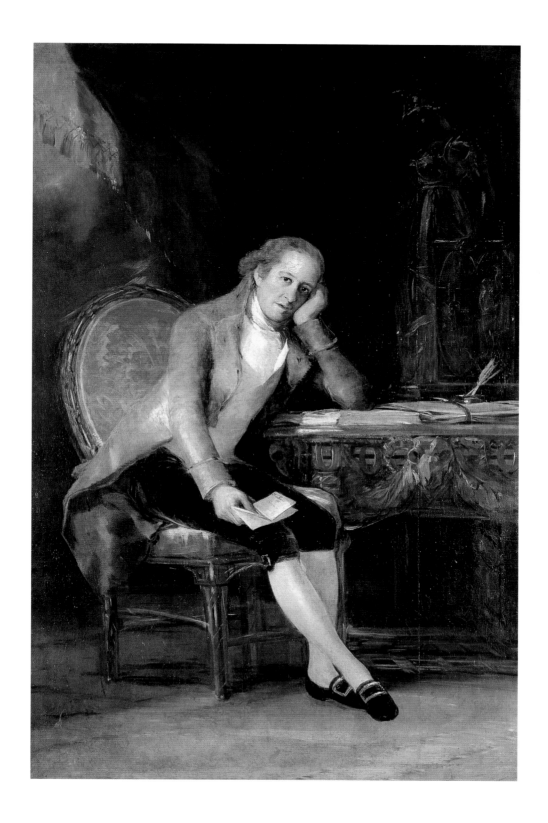

Ferdinand Guillemardet, 1798
Oil on canvas, 185 x 125 cm
Paris, Musée du Louvre

Wearing a tricolour sash, the French Ambassador to Spain poses in Madrid. He represents a new order; in 1793 he voted for the death of King Louis XVI, a cousin of the Spanish monarch.

ILLUSTRATION PAGE 24:
Don Manuel Osorio Manrique de Zúñiga, 1788
Oil on canvas, 127 x 101 cm
New York, The Metropolitan Museum of Art

Like Velázquez, Goya was also in demand as a painter of children. But behind the pretty young heir, two greedy cats are eyeing their victim. Early signs of danger lurking even in this idyll? Precursors of Goya's later demons?

ILLUSTRATION PAGE 25:
Gaspar Melchor de Jovellanos, 1798
Oil on canvas, 205 x 133 cm
Madrid, Museo del Prado

When this portrait was painted, Jovellanos (1744–1811) was Minister of Justice. The liberal patriot and nobleman fought – with increasing success – for reforms and against ignorance, superstition and the Inquisition.

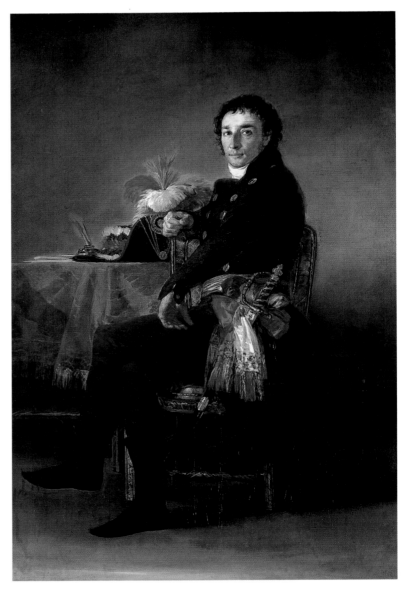

decorations or a wig, and sits not in a formal pose but at his writing desk, resting his head in his hand. Not a man who is trying to impress, but rather one who is thinking or is tired. Goya takes away the usual insignia of rank and power and shows Jovellanos as a man.

A comparison of these two portraits also reveals the artistic experience that Goya has gained over the years. Thus Floridablanca cuts a relatively wooden figure in his red robes, while the Jovellanos portrait reveals a far greater subtlety in its handling of colour. But Goya's omission of the symbols of rank also reflects a changing attitude towards the aristocratic hierarchy. The old belief that the King was appointed by God himself, and was answerable only to Him, was disap-

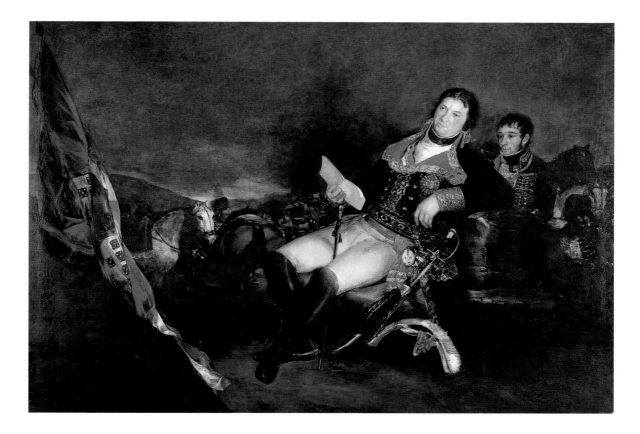

pearing. In France, the nobility had become *citoyens*, ordinary citizens like the rest of the French.

In Spain such revolutionary ideas were discussed amongst only a small circle. Separated from the rest of Europe by the Pyrenees, the Iberian peninsula lay out of the way and lagged behind in its social, economic and intellectual development. There were many reasons for this, one of which was the power of the Catholic Church. Living in Spain in 1787 were almost 150,000 members of the clergy, accounting for 4.5% of the population. They were the only ones allowed to teach, but even so reached only a fraction of Spanish children and bequeathed to them a religious rather than a rational understanding of the world. The level of education remained low, and hence dependence upon priests and monks high. According to one French envoy: "In Spain you have the common people with inferior taste, whose chief preoccupations are processions, bullfights and love in its most brutal form. The middle classes are dissatisfied and are afflicted by the general poverty, the clergy is ignorant and the nobility is dying of hunger on lands that are only half cultivated."

The Bourbon kings tried to curtail the power of the Church, but other than the fact that they drove the Jesuits out of the country, without any real success. The kings also looked favourably upon some of the "enlightened" ideas being expounded in France, as did Floridablanca and, in particular, Jovellanos. But when the French interfered with the monarchy, the situation changed. Floridablanca now sought to block all influences coming from France, while Jovellanos

Manuel Godoy as Commander in the War of the Oranges, 1801
Oil on canvas, 180 x 267 cm
Madrid, Museo de la Real Academia de Bellas Artes de San Fernando

The most powerful and most hated man in Spain, Godoy was simultaneously supreme commander of the Spanish forces, Prime Minister and Queen María Luisa's lover. Reclining nonchalantly on the battlefield, he enjoys a victory over Portuguese troops.

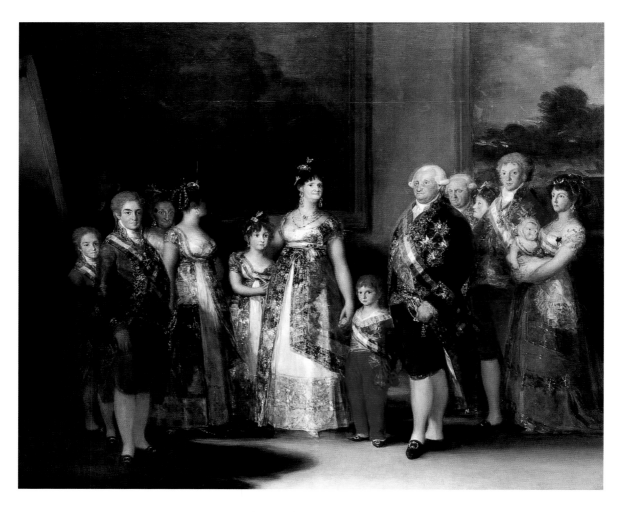

The Family of Charles IV, 1800–1801
Oil on canvas, 280 x 336 cm
Madrid, Museo del Prado

Goya has not flattered his models. In this
unembellished group portrait, he portrays the
royal clan that was trying to defy the changing
times. The family was evidently happy with
Goya's painting. The artist himself poses in the
background, no longer the humble servant but
a self-confident individual.

escaped into exile. As to Goya's own position, it can be said that he knew and
painted portraits of several representatives of Enlightenment Spain. Such *ilustra-
dos* included the Duke and Duchess of Osuna, whom Goya painted with their
children around 1788 (ill. p. 23). They called for economic reforms and better
schools and were generous patrons of art, buying over 30 paintings from Goya.

Amongst the men who directly or indirectly awarded the artist important
commissions was *Manuel Godoy*, the minister and favourite of Queen María
Luisa. He, too, was a social climber – his career was made possible by the dullness
and apathy of the King. María Luisa fetched the 25-year-old officer of the guard
into her bed, took over with him the running of the affairs of state, gave him one
of the Crown properties, and made him a duke, a member of the privy council,
general superintendent for road construction, head of the Royal Academy of
San Fernando, prime minister – and one of the most hated men in Spain.

In the war against Portugal of 1801, María Luisa appointed Godoy supreme
commander of all the Spanish forces, and it is in this military position that he
instructed Goya to paint him (ill. p. 27). The composition appears to borrow
elements of Baroque military portraits. While the commander may not be sur-

rounded by angels of victory or seated regally on a horse, he is portrayed on the battlefield, in ceremonial dress replete with ribbons and sash, engrossed in a letter or in studying the flags captured from the enemy. Realism is absent, as is any psychological differentiation; it is impossible to say to what extent this pictorial homage was formulated in consultation with the client or whether it perhaps reflects a degree of secret contempt. The staff gripped between the general's thighs, an ironic reference to Godoy's services in the Queen's bed, could hardly have been included without his agreement.

Goya treats *The Family of Charles IV* quite differently to the favourite. He does not flatter them; although he dresses them in sashes and lavish clothes, he includes no throne, no coats of arms, and does nothing to underline the illustrious rank of this family of kings and queens by the grace of God.

Goya painted the King as no more intelligent than he was, and he left the Queen her face. She was 48 years old, had borne 10 or 12 children, but is wearing a Cupid's dart in her hair in the latest French fashion. It is remarkable that she accepted Goya's likeness of her. Either she felt so superior to everyone else, due to her rank and power, that their criteria of beauty were simply irrelevant to her. Or she considered that Goya had captured her so faithfully and vividly that, again, no one else mattered. Perhaps both cases were true.

The six-year-old between the King and Queen was alleged to be a son of Godoy's, but information of this sort must be treated with caution; it was often disseminated by María Luisa's enemies. What cannot be denied, however, is the gap between the royal couple in Goya's painting. All the other figures are standing closely one behind or next to the other; only these two are given space between them, as if Goya were unable to find anywhere else to put the boy. This gap is accentuated by the vertical of the picture frame on the wall behind the group. The painting to which it belongs has been identified as *Lot and His Daughters*, one of the Old Testament examples of women acting out their unbridled sexual desires. Mere coincidence? It is conceivable that the artist, who is standing at his easel on the far left, is portraying the family from María Luisa's point of view, according to which one of its most important members is missing – her bedfellow and adviser Manuel Godoy. Together, María Luisa, Charles IV and Godoy formed "an unholy Trinity on earth" – a phrase the frivolous Queen coined herself. For Godoy was held in great esteem by the King, too, who refused to accept that Godoy was his wife's lover. Charles IV probably liked Godoy so much because he shouldered the burden of running the country for him, simply informing him every evening "whether affairs were going well or badly".

The family portrait, which hung in the royal palace, also contained something of a political message. In 1793 Louis XVI had gone to the guillotine and the rule of the Bourbons in France appeared to have come to an end. Not so in Spain, however, where the surviving members of the dynasty planned to expand and strengthen the family through strategic marriages. Thus María Luisa wanted to marry her daughter Doña María Isabel, whom she embraces here with her right arm, to Napoleon. The latter declined: "I would not turn to a house in decline in order to produce heirs".

The painting arose in 1800, the year in which the 30-year-old Napoleon conquered Italy, before occupying half of Europe and Spain, too, and installing his brother on the Spanish throne. After Napoleon's fall, Ferdinand VII – second from the left in Goya's portrait – became King. Ferdinand, a cruel and cowardly character, would revoke all the progressive reforms of the preceding years, force the country further into decline and prompt Goya, a frail old man, to emigrate.

Las Meninas (copy after Diego de Velázquez), 1778–1779
Etching with aquatint, 40.5 x 32.5 cm
Madrid, Calcografía nacional

Goya studied and copied the works of Diego de Velázquez (1599–1660) and drew inspiration from *Las Meninas*, his portrait of an earlier royal family. Goya's famous predecessor also included himself at the easel in his canvas.

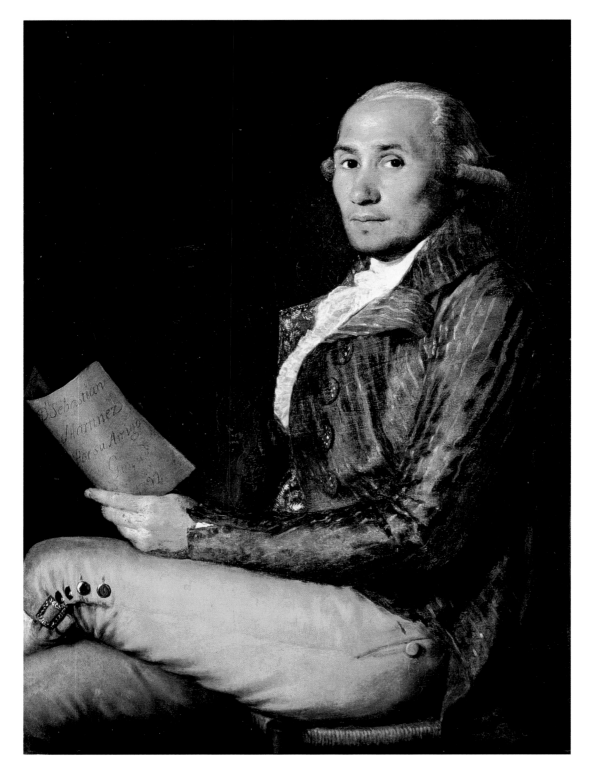

Nightmare and Social Critique – *Los Caprichos*

In his portraits Goya depicted the rich and the powerful, the individuals who dictated the direction taken by Spain and Spanish society. He also painted their families, children and his own friends. These were the faces that surrounded him and that formed part of the outside world in which he lived. From 1793 onwards, however, his painting also began to reveal the visions and nightmares he saw inside his head. The impetus for this new development came from a crisis, a breakdown. It carried him to the brink of death and robbed him of his hearing. The artist would be deaf for the rest of his life.

What precipitated this crisis is unknown. It may have been a purely physical illness. It is also possible that psychological factors played a part, however: perhaps these visions, these images of darkness and the unconscious, had been suppressed for too long. Suppressed because they were incompatible with progress and reason and had no place within the elegant world of his patrons.

In autumn 1792 Goya fell ill while in the south of Spain. He recuperated in the home of his friend Sebastián Martínez in Cadiz. In January 1794 he announced to the vice-director of the Royal Academy that he had completed a set of new works. These, Goya stressed, were very different from the norm, and represented "observations for which there is usually no opportunity in commissioned works, which offer no scope for caprice and invention".

These new works employed a small format (mostly 43 x 32 cm) and thus made no great physical demands on the artist. They include bullfights, the *Fire at Night* (ill. p. 33) and also a scene that Goya is more likely to have invented than actually observed: a *Yard with Lunatics* (ill. p. 32). Semi-naked men, enclosed within threateningly high walls, are grinning idiotically at the viewer, fighting, and being separated with a riding switch. A sombre vision of human bodies without human reason, a brutal contrast to Goya's portrait gallery.

Goya painted little over the next few years, but sought after forms in which he could free himself from the images in his head. These seemed to oppress him, like the owl-faced bats in *The sleep of reason produces monsters* (ill. p. 34), a nightmarish vision with a dangerous title – dangerous in a day in which reason was equated with the Enlightenment and the Enlightenment with France, the country that had murdered its king, queen and nobility.

The artist settled on the medium of etching. He was fascinated by the expressive possibilities of this – to him – new technique. It was something he could

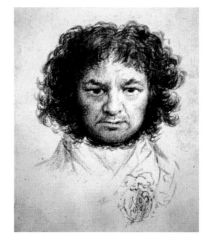

Self-portrait, 1795–1797
Indian ink wash, 23.3 x 14.4 cm
New York, The Metropolitan Museum of Art

During his illness in Cadiz, Goya went deaf. He surrounds his face with a dark wreath of tangled hair.

ILLUSTRATION PAGE 30:
Sebastián Martínez, 1792
Oil on canvas, 92.9 x 67.6 cm
New York, The Metropolitan Museum of Art

This aesthete and art collector, with his cosmopolitan, modern tastes, was a member of the progressive merchant classes. Goya stayed in his home in Cadiz during his lengthy illness.

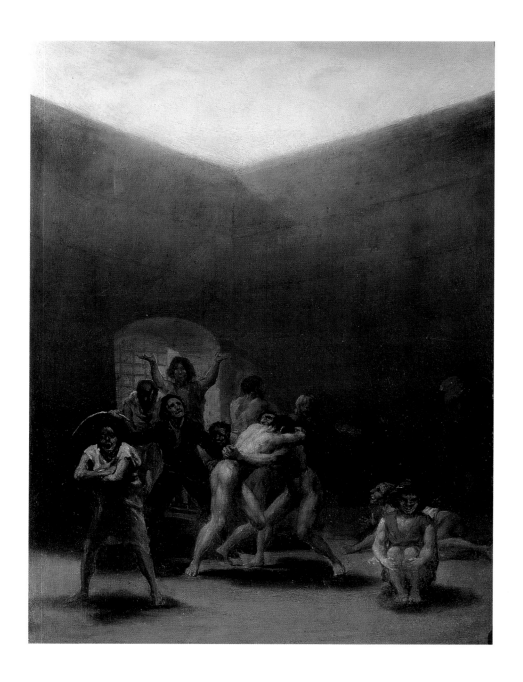

Yard with Lunatics, 1794
Oil on tinplate, 43.8 x 32.7 cm
Dallas, Meadows Museum

Between high walls, lunatics grin at the visitor. After
his illness, Goya resolved no longer to produce
commissioned works alone. He also painted his
own visions.

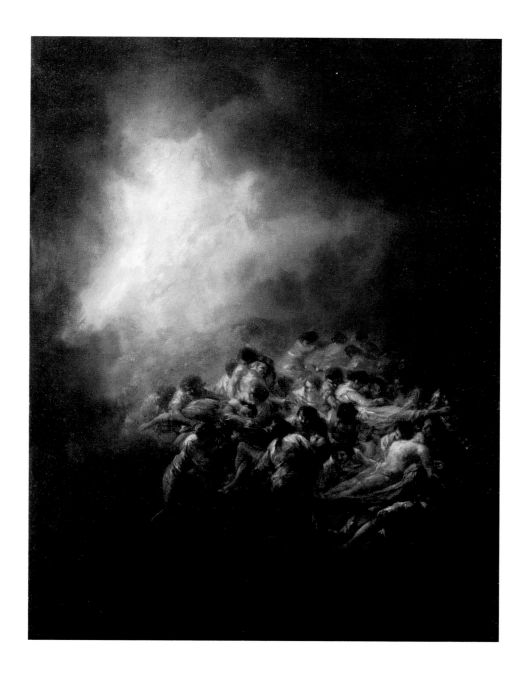

Fire at Night, 1793–1794
Oil on tinplate, 50 x 32 cm
Madrid, Banco Inversion-Agepasa

The uncommissioned subjects which Goya painted
during his convalescence included not only lunatics in a courtyard,
but also fires, shipwrecks and highway robberies.
His world was no longer as cheerful and bright
as the one he had been required to portray in his tapestry cartoons.

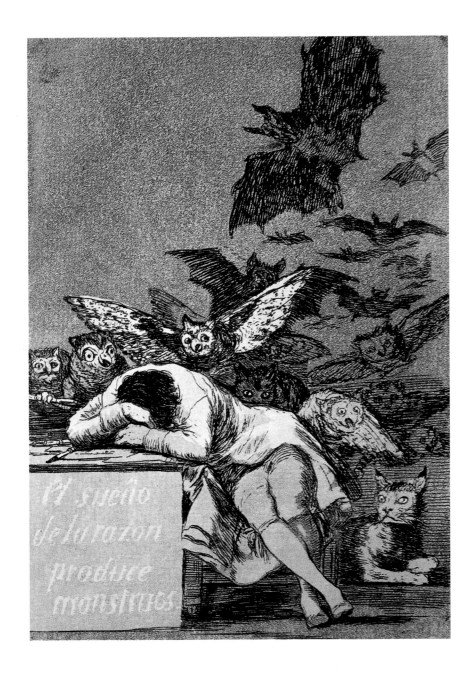

The sleep of reason produces monsters (*Capricho 43*),
1797–1798
Etching and aquatint, 21.6 x 15.2 cm

The etching of the sleeping artist, threatened by
fantastical faces, was originally intended to open the
Caprichos cycle. The title can be read on the stone.

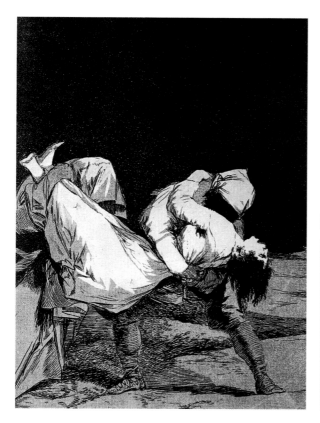

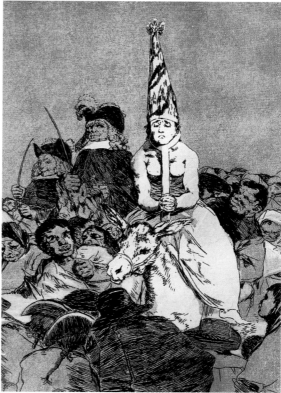

pursue alongside his commissioned work and offered him a means of reaching a wider public via large editions of small-format prints. The etching of the artist asleep at his desk belongs to the 80 plates making up *Los Caprichos*, which he published in 1799. *Caprichos* are "caprices"; the word implies very personal fantasies, perhaps even whimsies that no one need take seriously. An announcement of the publication of the series, carried in the *Diario de Madrid*, also promised "censure of human errors and vices" and of "the extravagances and follies common to every civilized society".

The etching of the sleeping artist being attacked in his dreams by night phantoms was originally intended to open the *Caprichos* series. Goya then decided to replace it, however, with a *Self-portrait*, the picture of a self-assured man dressed in a top hat and wearing a critical expression (ill. p. 1). Together, the two plates characterize this wide-ranging cycle, whereby it is not always possible to determine whether the artist is distancing himself from all the "human errors and vices" and "extravagances and follies" through his satirical use of line, or whether he feels himself to be their victim.

Or if not directly a victim, then perhaps as someone upset or angered by aspects of contemporary Spanish society, such as its vast numbers of hidalgos. The title *hidalgo* meant no more than its bearer was somebody's son (from *hijo de algo*, "son of someone"). Simply the fact that you could name a forebear was understood as ennoblement and hence a plausible excuse not to work. Physical labour, in particular, was to be avoided. Almost 15% of the population counted

ILLUSTRATION LEFT:
They carried her off (*Capricho 8*), 1797–1798
Etching and aquatint, 21.7 x 15.2 cm

One of Goya's particularly forceful indictments against violence towards women. The perpetrators remain anonymous; the one at the back is wearing a monk's habit. Only the woman's head is rendered in detail.

ILLUSTRATION RIGHT:
There was no remedy (*Capricho 24*), 1797–1798
Etching and aquatint, 21.7 x 15.2 cm

Those condemned by the Inquisition were publicly paraded wearing a distinctive conical hat signalling their disgrace. In 1807 a French traveller in Valencia watched an alleged witch, "her upper body bared to the waist", being led through every quarter of the town.

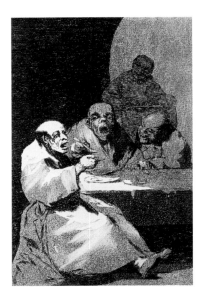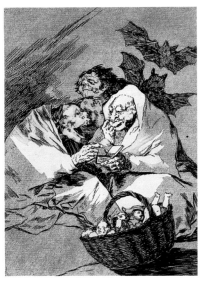

ILLUSTRATION LEFT:
They're hot (Drawing for *Capricho 13*),
1797–1798
Red chalk and red wash, 21.9 x 15.3 cm
Madrid, Museo del Prado

In all probability Goya was a faithful Christian,
but he hated the mass of 60,000 Spanish monks
as greedy and lazy, as encouraging superstition
and as profiting from the work of others.

ILLUSTRATION RIGHT:
There is a lot to suck (*Capricho 45*), 1797–1798
Etching and aquatint, 20.8 x 15.1 cm

In a similar fashion to the greedy monks, Goya
also portrays one of the witches with her mouth
wide open. They are catching infants in order
to feed off their blood. A superstition which
may be connected with the fact that women
who assisted at abortions were denounced as
witches.

themselves amongst the nobility in this fashion and thereby shirked productive work. Goya describes them as asses. They leaf through family albums full of pictures of more asses (ill. p. 39) or, as impoverished landowners, sit astride the backs of their day labourers, forcing them to the ground under their great weight.

Satirical portrayals of society were widespread in the 18th century. One of their greatest exponents, William Hogarth (1697–1764), used his paintings and engravings to denounce the English elections, the evil influence of gin and the unhappy consequences of forced marriages. But Hogarth always keeps his distance; it is as if his scenes are being acted out on a stage. In Goya's works, there is no such sense of theatre. The viewer is taken right to the heart of the action, is directly confronted by the huge figure of a monk with his arms threateningly raised (ill. p. 38 left). A terrifying spectre from one of Goya's own dreams? The truth is quickly exposed – it is just a monk's habit that has been hung over a dead tree. As the title laconically observes: *What a tailor can do!*

In some dozen plates Goya attacks the power wielded by the monks, the clergy and the officials of the Inquisition. For him, they are figures of hate of the highest order. Goya thereby reveals himself firmly on the side of the Enlightenment. What seems to have enraged him in particular was the fact that the Church encouraged superstition. Even as it persecuted and condemned witches and sorcerers, it thereby affirmed their existence. In Goya's work, such figures belong – like the giant bats – to the realm of night-time apparitions. Whereby it is not always clear to what extent the artist is the hunter or the hunted.

The position of the Duchess of Osuna, who asked Goya to paint a series of witchcraft scenes, is similarly unclear. The Duchess undoubtedly numbered amongst the intelligent, enlightened women of her day, yet she commissioned for her private collection six small-format paintings devoted to such subjects as *Witches in the Air* (ill. p. 37). Perhaps she liked the shiver of such stories and characters.

Goya executed his *Caprichos* series not just with an etching needle alone. In the technique of etching, the artist uses a needle to draw his design in the wax

ILLUSTRATION PAGE 37:
Witches in the Air, 1797–1798
Oil on canvas, 43.5 x 31.5 cm
Madrid, Museo del Prado

Witches are sucking the blood out of the body of
someone dead or dying. The man with the cloth
over his head is making a sign with his hands to
ward off evil spirits.

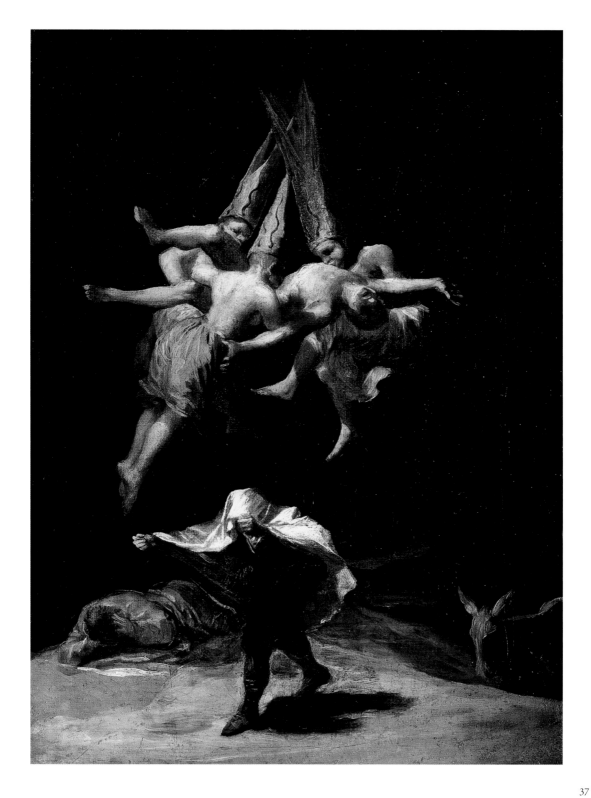

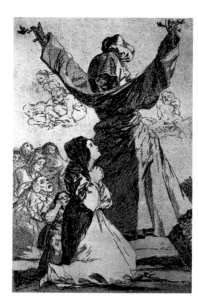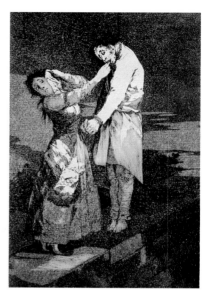

ground which coats the copper plate. The plate is then immersed in acid, which
penetrates the lines scored through the wax and bites into the exposed metal be-
neath. The indentations thus created in the plate hold the ink used in printing.
Etching is an art of the line. If an artist wishes to produce dark areas on the final
print, he must score lines very closely together or in a criss-cross fashion. In
Goya's etchings, however, we find areas that are uniformly grey or black yet
whichout hatching. He achieved this effect by using aquatint, a technique de-
veloped some 30 years earlier in France, whereby the plate is sprinkled with tiny
particles of acid-resistant dust, in a more or less dense layer depending on the ef-
fect required. When the plate is immersed, the acid eats into the minute spaces
between the particles, yielding the impression of uniform shading. The dramatic
effects that can thus be achieved are illustrated by the print of two men carrying
off a woman (ill. p. 35 left). The ground is empty, the sky black. Black and con-
cealed, too, are the faces of the men. Only the face of the woman and parts of the
clothing gleam a brilliant white. Even more than the drawing, it is the extreme
contrast between light and dark, made possible by the use of aquatint, which
lends this image its particular sense of brutality and hopelessness.

In 1799 Goya advertised *Los Caprichos*: "Obtainable from the perfume and
liqueur shop at 1, Calle del Desengaño, for the price of 320 *reales* per set of
80 prints". A kilo of bread cost 6 *reales*; Goya's series thus cost the equivalent of 53
kilos of bread. After only a few weeks, he withdrew the prints from sale, probably
under pressure from the people who felt attacked, in particular the clergy. In 1803
Goya presented the remaining unsold sets and the original plates to the King,
who passed them on to the Royal Calcography, where they are still housed today.
In return for his "gift", Goya was promised an annuity for his son, Javier.

It was most certainly Godoy and the Queen who recommended the King to
purchase the plates. They valued their artist, and by acquiring the plates, were
also protecting him. Not until the middle of the 19th century, long after Goya's
death, were the *Caprichos* printed again in their entirety. It would be his etchings,
not his paintings, that would establish Goya's fame in Europe.

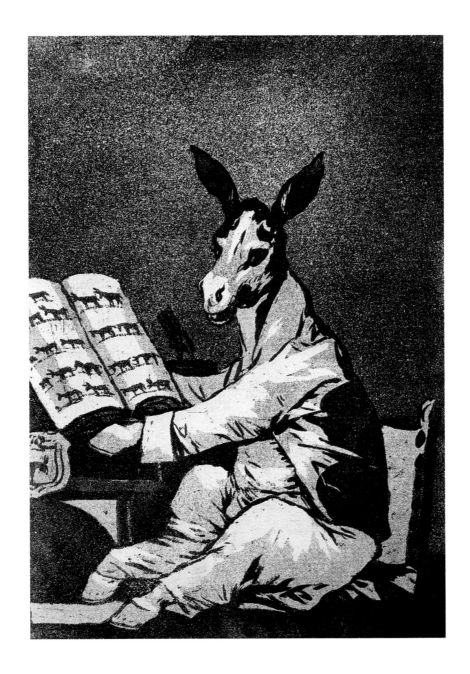

As far back as his grandfather (*Capricho 39*), 1797–1798
Aquatint, 21.5 x 15 cm

Goya caricatures the pride of the hidalgos. Some
500,000 of Spain's population of around 10 million
considered themselves to belong to this lesser branch of
the nobility. Since work was beneath their station, most
of them were impoverished, their only possessions
being a long line of ancestors.

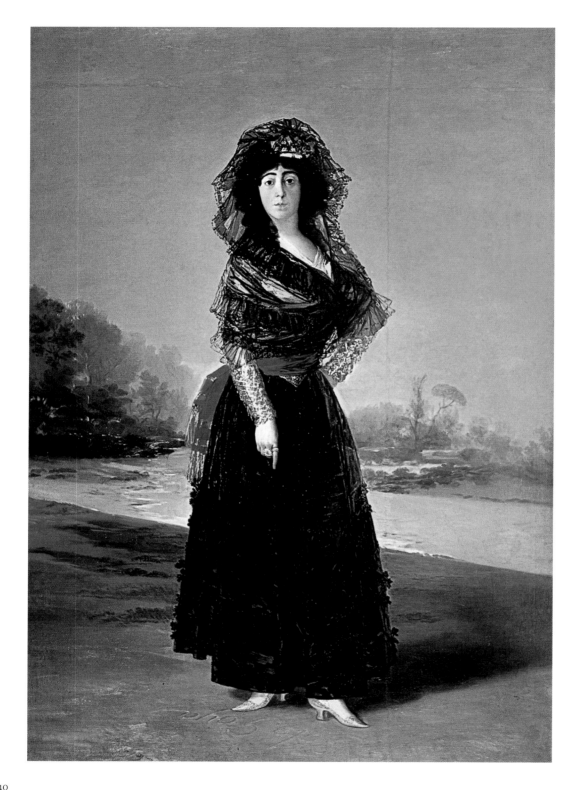

They Don't Smile – Spain's Women

The Duchess of Alba visited Goya in his studio one day and asked the artist if he would put on her make-up for her. "That is certainly more of a pleasure than painting on canvas!", Goya wrote to a friend. In the hierarchy of Spanish society, the Duchess of Alba came directly after the Queen; the painter's humble origins, on the other hand, placed him on one of the lowest rungs. It was an unusual request, but it fits in with the Duchess of Alba's reputation as someone who was extremely attractive but also spoilt, egocentric and provocative. As one French-man noted: "When she passes by, everyone goes to the window …!" The Queen considered her to be "still as giddy as in her first flush of youth".

The make-up episode probably occurred in 1795, the year in which Goya painted the portraits of both the Duchess of Alba and her husband. She had been married to him when she was thirteen; they had no children. The Duke died in 1796. His widow withdrew, as custom demanded, to one of her country estates, the summer residence of Sanlúcar in Andalusia. Goya followed her. Sketches, etchings and a painting are all the evidence we have of the months Goya spent with the young widow in Sanlúcar; nothing in writing, no allusions or anecdotes. No other woman appears in his art as frequently as the Duchess. Even those sketches from this period which do not specifically depict the Duchess are, in many cases, still so like her that it is as if Goya were thinking only of her. Every-thing points to them spending their days together. The *Portrait of the Duchess of Alba in Black* of 1797 documents how the artist saw her. He places her in a land-scape free of subsidiary detail, a sovereign figure dressed not in the latest French fashions, but as a *maja*, as if she were a woman of the people. Imperiously, she points at the sand beneath her feet, where the words "Solo Goya" – "Only Goya" – are written. On her fingers she wears a diamond into which the name "Alba" is cut, and a gold band on which the name "Goya" is clearly legible.

The painting claims that only Goya is important to her. The Duchess – from a certain, unknown point onwards, at least – may have viewed their relationship differently. She had just buried a husband she didn't love and was surely not will-ing to be tied down again straight away, at least not by an ugly, deaf, 50-year-old man of lowly birth. Perhaps the whole thing was just a game for her right from the start – a game on the one hand with the artist genius, and on the other with social conventions. For her an affair, for him a catastrophe, both as a man and as a social climber who wanted to rise to the top.

Portrait of the Duchess of Alba (detail), 1795
Oil on canvas, 194 x 130 cm
Madrid, Collection of the Duchess of Alba

ILLUSTRATION PAGE 40:
***Portrait of the Duchess of Alba in Black*,** 1797
Oil on canvas, 210.2 x 149.3 cm
New York, The Hispanic Society of America

The aristocratic, extravagant Duchess had Goya paint her portrait and apply her make-up. Does the inscription "Solo Goya", "Only Goya", written in the sand at her feet, betray her feelings for the artist or simply Goya's own secret wish?

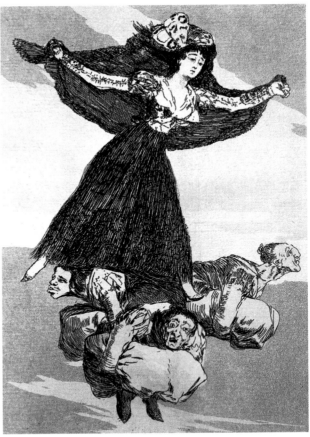

Goya took the portrait back to Madrid with him and kept it for himself. The
Duchess appears again in his *Caprichos*: standing proudly on the back of three
witch-like figures, she flies through the air (ill. p. 42 right). The heads of the
figures resemble those of famous bullfighters. The white, doll-like face of the
Duchess appears haughtily reserved, and in her hair she wears butterfly wings
as a symbol of unpredictable flightiness. Five years after Goya painted her as a
maja, she died at the age of 40. One of her many female enemies had had her
poisoned, so it was said.

The Duchess and also Queen María Luisa, who duped her husband and
appointed her lover prime minister, illustrate in an extreme fashion a general
change taking place in Spain. For a long time, the Spanish women of the upper
classes had lived a much more cloistered life than their counterparts elsewhere
in Europe. They were treated as minors who had to be protected and shut away
from the eyes of men. This attitude towards women was part of the heritage of
the Moors, who had been driven out of Spain 300 years previously. In Goya's day,
however, women began to be granted a cautious degree of emancipation. As in
Italy, a married woman was now permitted to choose a *cortejo*, an unmarried
man from the same social class, to escort her when she wished to leave the house.
She was also permitted to host and attend *tertulias*, social receptions for both
women and men. In the past, the two sexes had lived largely separate lives. The

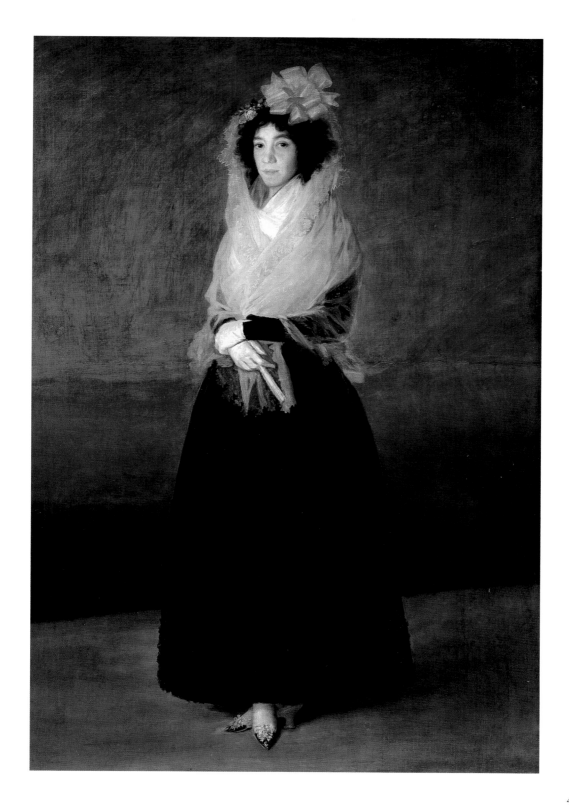

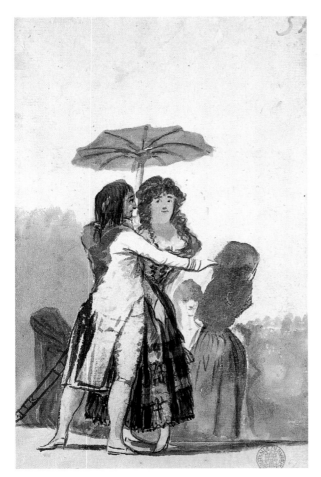

famous Royal Economic Society in Madrid, a debating club for men, even
founded a ladies' section, which for a long time was chaired by the Duchess
of Osuna.

The longing amongst the women of the upper classes for the greater independence already enjoyed by those of the lower classes, such as the *majas*, also
expressed itself in their imitation of *maja* fashions. The lace shawl or the ankle-
length dress symbolized for them an affirmation not just of their allegiance to
Spain and all things Spanish, but also of greater freedom. Their husbands only
very rarely dressed as *majos*; why should they indeed, when they already enjoyed
the liberty that women had yet to command? Women's aspirations were encapsulated in the 18th century in the term *marcialidad*, "martialism". According to
a text of 1774, *marcialidad* included speaking freely without blushing, discussing
all topics of interest, and abolishing old-fashioned ideas of respectability, for
example, that a dress should cover the foot and a veil the face. In the 19th century,
a romanticized form of this *marcialidad* would be personified in the figure of
Carmen in Georges Bizet's opera of the same name, based on the story by
Prosper Mérimée, a Frenchman like Bizet.

A reflection of *marcialidad* seems to fall across the faces of many of Goya's *majas*, countesses and duchesses. They look out at the viewer almost coldly, as if wishing to communicate that they will allow no restriction of their movements. But Goya also painted young women listening to the strains of a guitar, on a balcony or reading a letter. He portrayed the pregnant Countess de Chinchón, folding her hands submissively over her abdomen, and caricatured old women who bedecked their shrivelled bodies with jewellery. Again and again, too, he brings in La Celestina, a literary figure created by Fernando de Rojas (c. 1465–1541) who – like Don Juan – stepped off the page to become a stock character in Spanish society. Celestina is the old matchmaker, prospecting for wealthy men for the young girls under her protection; the hideous old hag who deals in youthful beauty.

During Goya's lifetime, civil war and famine forced many Spanish women to abandon their feminine reserve. In his etchings *The Disasters of War*, women commit murder and are murdered themselves, lie bound on prison floors, starve, and are tipped, dead, off carts of corpses. Apart from William Hogarth, whose portrayals of English society in any case tended largely towards caricature, there

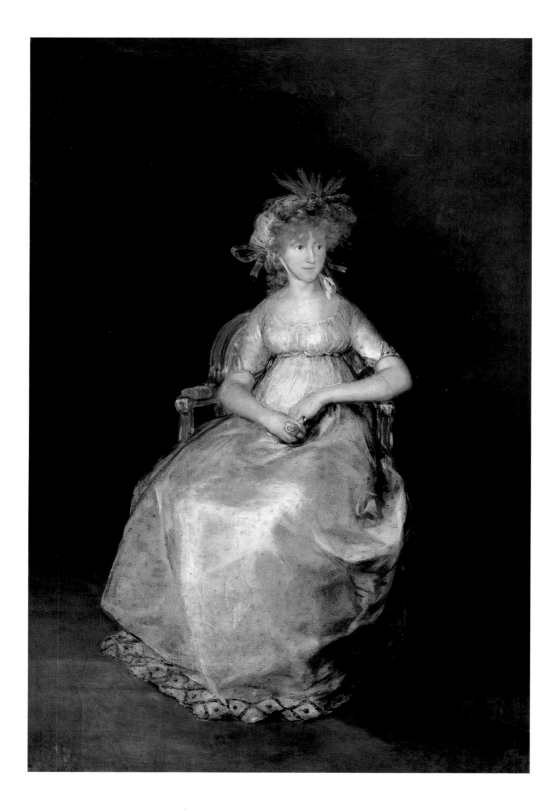

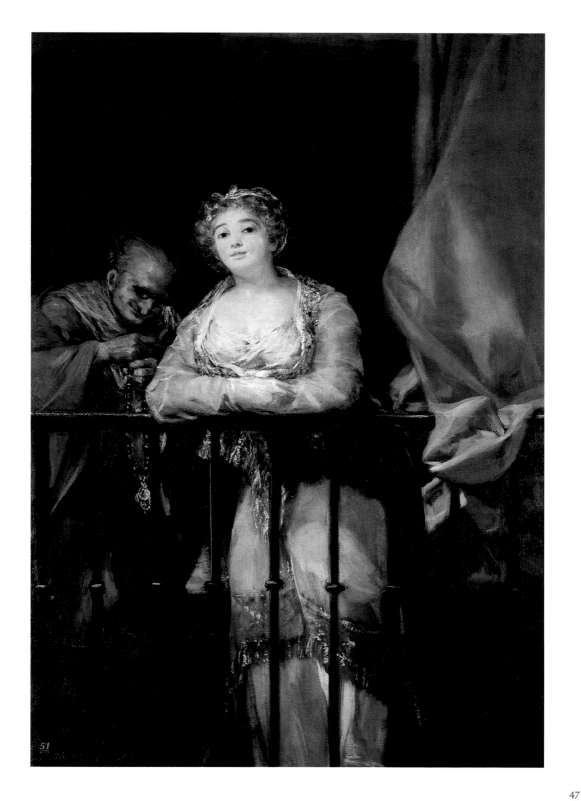

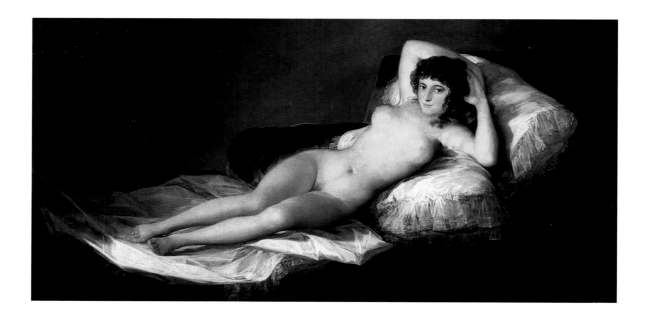

Naked Maja, 1797–1800
Oil on canvas, 97 x 190 cm
Madrid, Museo del Prado

She gazes coolly at the man for whom she has undressed. Pictures of nudes were forbidden in Spain, and only Godoy, the powerful minister, could dare to commission one for his collection. After his fall, the work earned Goya an invitation to appear in front of the Inquisition, the guardian of public morals.

Diego de Velázquez
Venus at her Mirror, c. 1651
Oil on canvas, 122.5 x 177 cm
London, National Gallery

Velázquez had already risked painting a female nude for King Philip IV, but had presented her as a Greek goddess, accompanied by a winged Cupid and viewed discreetly from the rear.

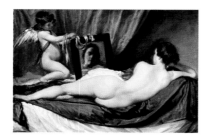

was probably no other artist in either the 18th or the 19th century who portrayed women in such different roles and situations. Not the usual Greek goddesses, raped Sabines or moral ideals such as Lucretia, who took her own life, but the women of Goya's day. He painted what he saw, and thereby regularly gave offence.

As in the case of his *Naked Maja* (ill. p. 48). In Spain, pictures of nudes were forbidden by the Church and impounded by the Inquisition. In the 18th century, two of the Spanish monarchs, probably on the recommendation of their confessors, even wanted to burn all the nudes in the royal collections. On both occasions the paintings in question – which included masterpieces by Titian and Velázquez – were saved by other lovers of art.

The most important nude in the history of Spanish art before Goya was painted by Velázquez – not as a real woman, however, but as *Venus at her Mirror*, today known as the *Rokeby Venus* (ill. p. 48 bottom). Velázquez gave her a winged boy, a Cupid, as a companion and thereby elevated the reclining beauty out of the bedroom and up into the heights of mythology. She is lying with her back to the viewer, so that both her bosom and pudenda remain hidden. Goya, on the other hand, seeks no mythological excuse for his nude, whose body is turned towards the viewer and whose hands are clasped behind her head and not, as is common in many other female nudes, over her pubic area. Elsewhere in Europe, Venus had been appearing naked in art since the Renaissance. Usually she was to be seen smiling graciously or with her eyes closed, allowing the viewer to approach her unseen. Not so in Goya's painting. His *maja* fixes the person for whom she has taken off her clothes with a critical gaze, does not smile, remains matter-of-fact, preserves an air of *marcialidad* – and in precisely this way issues a defiant challenge to the client or the offended viewer.

Goya painted his *Naked Maja* between 1797 and 1800 for Manuel Godoy, the Queen's minister and lover. Only a man as powerful as Godoy dared directly contravene the directions issued by the Holy Office. *Maja Clothed* followed

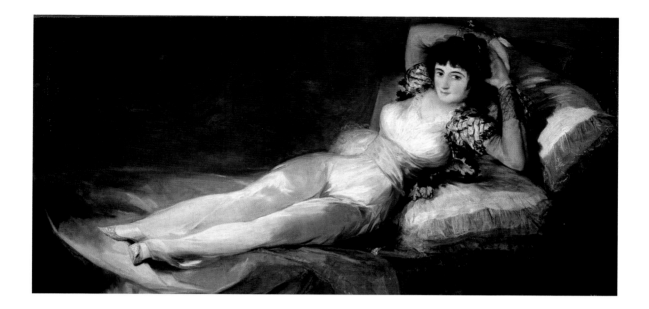

between 1800 and 1805 (ill. p. 49), and it is thought that Godoy showed his guests either the naked or the clothed version, depending on who they were. He also owned Velázquez' *Venus*. In 1815 Godoy was thrown out by the new King Ferdinand VII and his collection of paintings seized. The Inquisition summoned Goya to court, where he had to defend his *Naked Maja*. Although he was not punished, he knew that the Holy Office was keeping a close eye on him.

Amidst the wealth of women whom Goya captured in his art, one is missing – his wife, Josefa Bayeu. She was born in 1748, married Goya in 1773 and bore him six children, of whom only one son, Javier, survived infancy. She died in 1812. They were married for almost 40 years, yet in all of Goya's œuvre she can be identified with certainty only once, not in a painting, but in a black chalk drawing, and seen not from the front as conventional in portraits, but in profile, as an old woman (ill. p. 92 bottom). One year after Josefa's death, Leocadia Weiss moved in with the 68-year-old widower. She was 25, was separated from her husband and brought with her two children, whose biological father may have been the artist. She remained with him until his death. He probably painted her twice, once as a portrait and a second time in the so-called "black paintings" in his country house – but in the absence of any written evidence, even this is uncertain. Of himself Goya executed over a dozen portraits.

Maja Clothed, 1800–1805
Oil on canvas, 95 x 190 cm
Madrid, Museo del Prado

After the naked version, Godoy also commissioned a clothed *maja*; he probably showed his guests one or the other version, depending on who they were. The suggestion that the Duchess of Alba served as the model for the two paintings is pure legend.

Les Jeunes* or *The Young Ones, 1812–1814
Oil on canvas, 181 x 122 cm
Lille, Palais des Beaux-Arts

As in one of his early tapestry cartoons, Goya portrays
a fashionably dressed lady of the upper classes beneath
a parasol with her maid and little dog. He now contrasts her,
however, with the common people: bent down in the background,
a laundress can be seen at her work.

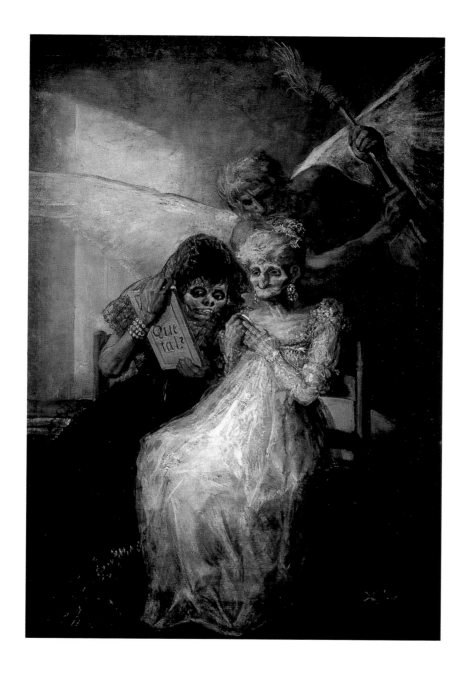

Les Vieilles *or* ***Time and the Old Women***, 1810–1812
Oil on canvas, 181 x 125 cm
Lille, Palais des Beaux-Arts

Chronos, the cruel god of Time, spreads his wings behind the two old
hags. With their faces made up and dressed in their finery (one of them
is wearing a love dart in her hair, as Queen María Luisa had done), they
are still asking the mirror: "Que tal"? – "How are you?"

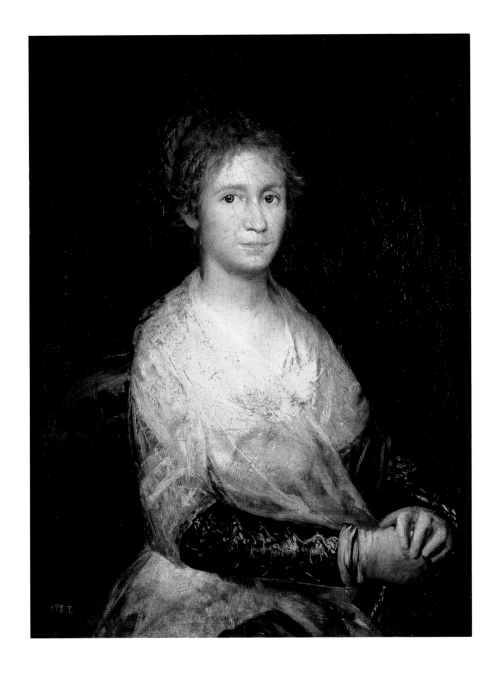

Josefa Bayeu (*or Leocadia Weiss?*), c. 1798 or 1814
Oil on canvas, 81 x 56 cm
Madrid, Museo del Prado

Depending on how they date this painting, art historians see in it a
portrait either of Goya's wife Josefa or of his subsequent partner Leocadia
Weiss, who moved in with the artist in 1813, just one year after Josefa's
death, and lived with him until his death.

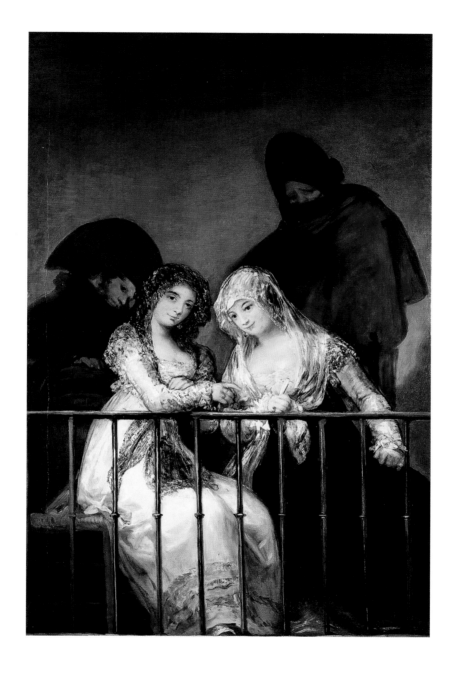

Majas on a Balcony, 1800–1814
Oil on canvas, 194.8 x 125.7 cm
New York, The Metropolitan Museum of Art

Supervised by the threatening figures of two heavily-cloaked *majos*, two
majas look down upon the passers-by. One even gives a hint of a smile,
highly unusual for Goya's women. Since 1995 the authenticity of this
canvas has been in doubt.

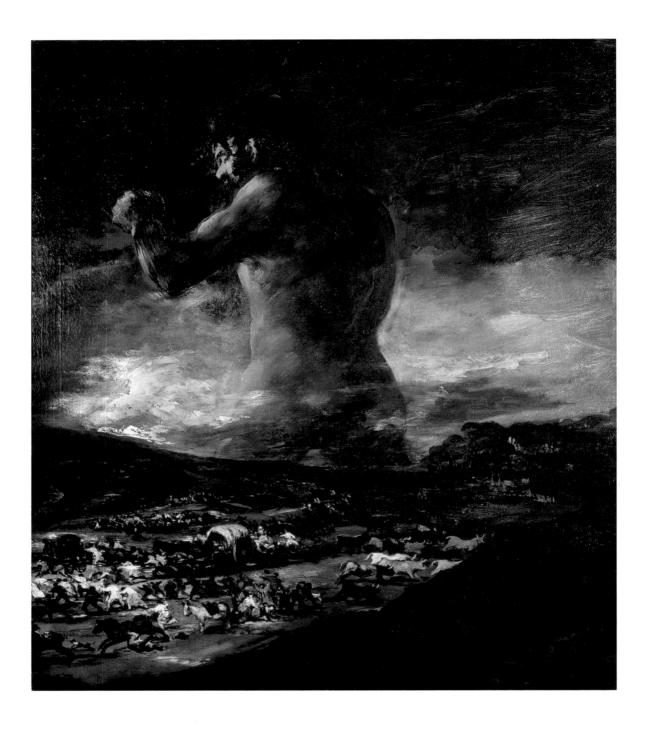

One can't tell why –
The Disasters of War

In 1807 French troops crossed the border; in 1808 they reached Madrid. Like many of his liberal, Francophile compatriots, Goya was plunged into a dilemma. On the one hand, Madrid's *ilustrados* hoped the French would implement the reforms they themselves desired; on the other, however, they felt their national pride as Spaniards had been wounded.

On 2 May there was a commotion in Madrid. A French soldier was pulled off his horse and almost lynched. General Murat announces: "French blood has flowed. It demands vengeance!" Any Spaniard found with a weapon in his possession – and virtually every Spanish man carried a knife – was to be shot. Some 400 ordinary citizens – beggars, craftsmen, monks, and farmers who had come to sell their produce at market – were arrested and, on the morning of 3 May, executed. The massacre served to spark off a national uprising, a struggle for independence fought by the Spanish people against the occupying French forces.

Goya, at the age of 62 already an old man by the standards of his day, kept a low profile. How much he witnessed at first hand is unclear. It is known that, in October 1808, he travelled to Saragossa, the city in which he grew up; he was to celebrate the heroic defence of the city in a painting. Although the work was never executed, he went on to produce an etching portraying the heroic act of a young woman, Agostina de Aragón (ill. p. 58). After all the men had fallen, she had fired a cannon, and the shot had driven back the French from the walls of Saragossa. Goya omits both the enemy and the city, and shows only the cannon and the fragile woman mounting a heap of corpses.

By December Goya was back in Madrid. Napoleon had installed his brother Joseph Bonaparte on the Spanish throne, and like all heads of families Goya had to swear an oath of allegiance to him. In 1810 he painted Joseph Bonaparte as part of an allegorical representation of the city of Madrid. He continued to earn his living with portraits of members of Spanish society and French individuals, and painted *majas* and genre scenes. His main subject, however, was war – the guerrilla war being waged by the Spanish against Napoleon's soldiers and characterized by an outburst of hatred and cruelty on a scale unprecedented in the history of European warfare. Goya filled the pages of his sketchbook with scenes of murder, torture and rape, and transferred these to etchings. He chose 82 of the resulting plates to form his cycle *Los Desastres de la Guerra – The Disasters of War.*

The Second of May, 1808 (detail), 1814
Oil on canvas, 266 x 345 cm
Madrid, Museo del Prado

ILLUSTRATION PAGE 54:
The Colossus, 1808–1812
Oil on canvas, 116 x 105 cm
Madrid, Museo del Prado

Napoleon's troops have occupied Spain. It is unclear whether the colossal figure, before whom people and animals are fleeing in panic, is meant to symbolize the foreign soldiers, the murderous guerilla war or a metaphysical threat.

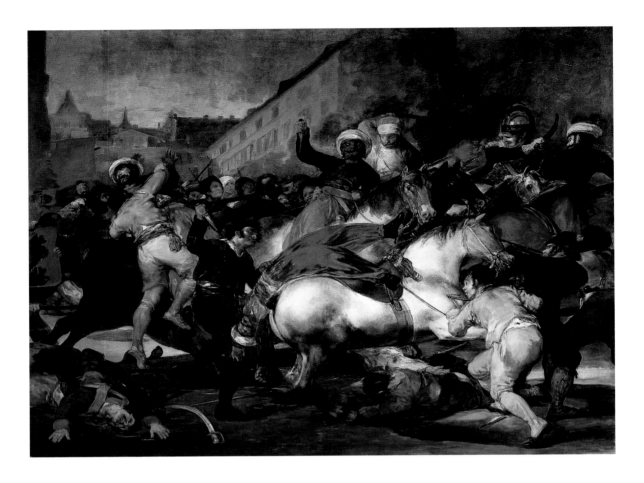

The Second of May, 1808, 1814
Oil on canvas, 266 x 345 cm
Madrid, Museo del Prado

On 2 May there was a commotion in Madrid.
A French soldier was pulled off his horse and
almost lynched. General Murat announces:
"French blood has flowed. It demands
vengeance!" Mamelukes of the Imperial Guard
are attacking furiously, and the Spanish are
defending themselves with knives. In Goya's
painting it remains uncertain who will win.

They are images which demonstrate no one-sided support either for the
ideals of the French Revolution or for the glorious name of Goya's own country.
They show the slaughter of both French and Spanish, and it is often impossible
to tell for which side people are killing or dying. This was new in the history of
Western art. Since the Egyptians and Greeks, the portrayal of battle had invari-
ably served to glorify the victor. Only victors wanted to see their deeds preserved
for posterity, in works of art they commissioned themselves. Goya's etchings
were not commissioned, however and the plate of the woman at the cannon
remains the only one in which any trace of heroism is present. Nor are there
any victors. Goya is interested only in what people do to each other, in how
chaos and war turn peaceful citizens into brutal beasts.

In taking this new look at war, Goya also found new means of expression, as
illustrated by a comparison of two etchings of hanged men (ill. p. 59). The earl-
ier, published in 1633, is by Jacques Callot and depicts a mass hanging conducted
during the Thirty Years' War. Almost two dozen men have been hanged from the
branches of a tree. The tree stands in the centre of the scene, and the hanged men
are distributed evenly along the branches on either side of the trunk. The com-
position is harmoniously balanced and its layout clearly structured; from a for-
mal point of view, there is a pleasing order to this scene of mass murder. This

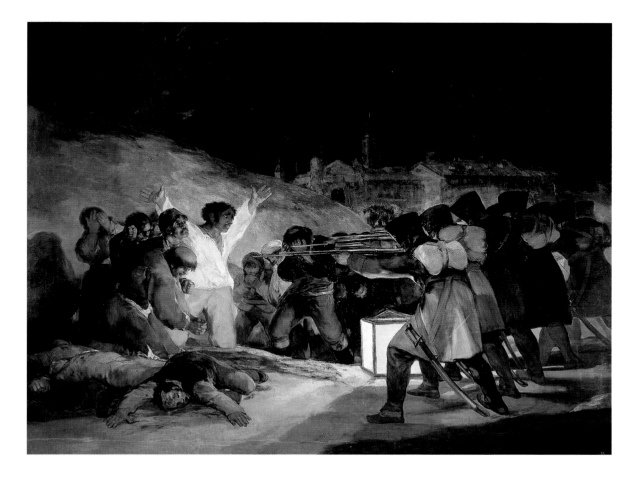

sense of order is confirmed by the accompanying verses, which identify the hanged men as bandits who have met their well-deserved fate.

Almost 200 years later, Goya, like Callot, would also emphasize the central axis – not with the trunk of a tree, however, but with the body of a dead man. And unlike Callot, who kept the gruesome scene of death at a distance, Goya places the hanged man right in the foreground. Nor does he create a three-dimensional setting within which the viewer can place the figures; rather, he offers only fragments of a landscape with a bush and two other topped trees with figures strung from them. Everything seems placeless and meaningless. The French soldier is leaning back with a relaxed air, as if after a job well done. His face reveals neither satisfaction nor hatred. The stone plinth against which he is reclining was probably intended to bear an inscription, but it is empty. Goya characterized each of his *Disasters of War* etchings with brief phrases. The present plate thereby relates back to the one immediately preceding it in the series, which is captioned *One can't tell why*. The word *Tampoco* beneath the figure of the hanged man states baldly: *Here neither*.

The Disasters of War are often taken as offering an authentic record of the guerrilla war and its particular atrocities, but apart from corpses, the wounded and the starving, it is unlikely that the artist saw very much at first hand. He was

The Third of May, 1808, 1814
Oil on canvas, 266 x 345 cm
Madrid, Museo del Prado

On 3 May some 400 Spaniards, arrested the day before, were executed by French firing squads. The massacre sparked off a nationwide uprising.

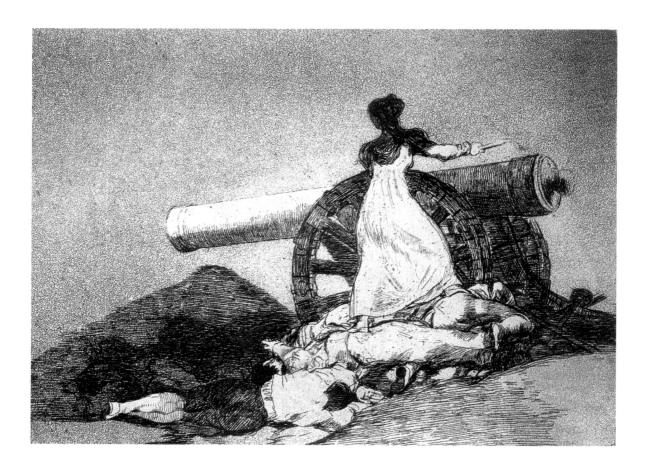

What courage! (*The Disasters of War 7*),
1810–1815
Etching and aquatint, 15.5 x 20.8 cm

Goya reacted to the struggle against the French
with *The Disasters of War*, his second great cycle
of etchings after *Los Caprichos*. It extends to over
80 plates, but includes only few acts of heroism,
such as that of the young woman who fires the
cannon after all the men are dead.

ILLUSTRATION PAGE 59 TOP:
Here neither (*The Disasters of War 36*),
c. 1812–1815
Etching and aquatint, 15.8 x 20.8 cm

Contemplating the man who has just lost his life
is a uniformed soldier, leaning back in a relaxed
fashion. Like him, Goya too questions the sense
of killing.

not a war correspondent; rather, he illustrates the products of his imagination.
And as in *Los Caprichos*, his imagination is dominated by the anxieties and sense
of menace that overshadow him. Such fears may have been heightened by his
deafness, which results in a loss of orientation that in turn engenders insecurity.
As in the past by giant bats, he was now tormented by visions of torture and
murder. These extended far beyond the realm of reality, as apparent in the etch-
ing of the naked man impaled on a tree trunk. In another plate, two uniformed
men are stretching apart the legs of a naked man, while a third slices at his
genital area with a sabre (ill. p. 61 bottom). Women in *The Disasters of War* are
assaulted, bound, murdered, but never mutilated in such bestial fashion. Goya
reserves this form of death for men. Male fantasies are what lend these images
of war their distinctive flavour.

In 1813 Napoleon returned from Russia with the remains of his *Grande Armée*
and was defeated at Leipzig. The end of his reign was clearly in sight. Joseph
Bonaparte left Madrid and Ferdinand VII, the son of María Luisa and Charles
IV, returned. He re-established the old absolutist system, brought back the In-
quisition, and restored to the Church its property, its exemption from taxation
and thus its former power. A wave of purges now began. A special committee
"orders the arrest of anyone whose opinions it considers suspect", wrote the
Prussian envoy. "The number of victims being thrown into gaol alongside rob-

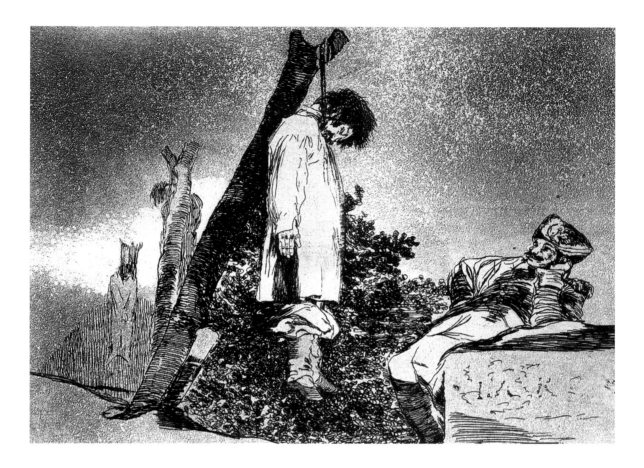

bers and murderers is countless, and they include amongst them many men distinguished by their talents and services to their country. What makes this despotism all the more outrageous is the fact that it is exercised by fanatical, avaricious, vengeful priests devoid of all talent or moral sensibilities. The finances are in hopeless confusion."

The purges drove 50,000 Spaniards into exile. Goya – he, too, a collaborator in Ferdinand's eyes – remained. Did he feel too old to leave? Did he think his celebrity status would protect him? Was he unwilling to lose his Court Painter's salary? He was hauled up in front of the Inquisition to answer for his *Naked Maja*, but was not sentenced. Witnesses had to testify that he had "emphatically refused all contact with the usurper government". Goya had already written to the new rulers to express his "ardent wish to immortalize with the brush the most memorable … scenes from our glorious uprising against the tyrants of Europe". The authorities showed themselves merciful: not only did they assume the costs of the canvases, stretchers and paints for two large-format paintings, but they also paid the artist an allowance for the duration of the project. In 1814 Goya also delivered six portraits of the new king, executed on his own initiative.

The two paintings *The Second of May, 1808* (ill. p. 56) and *The Third of May, 1808* (ill. p. 57) are as vivid as if the artist had hastened straight back to his studio from the scene of action. In reality, they were executed six years after the event

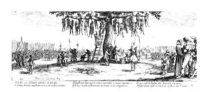

Jacques Callot
The Hanged (from *Les Grandes Misères de la Guerre*), 1633
Etching, 8.2 x 18.6 cm
Ann Arbor, Michigan, The University of Michigan Museum of Art

Callot had already engraved the horrors of war even before Goya. His image of hanged men leaves no doubt as to the reason for their mass murder: accompanying verses identify the victims as bandits. Approximately the same number of bodies are hanging from either side of the tree, and pikemen are standing to the left and right in the background. From a formal point of view, there is a pleasing order to this scene of mass murder.

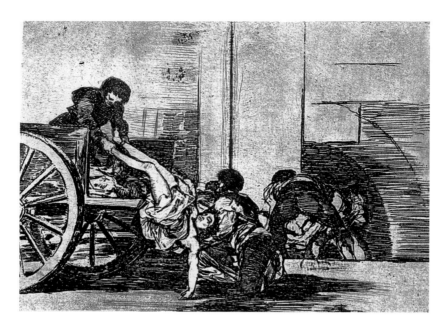

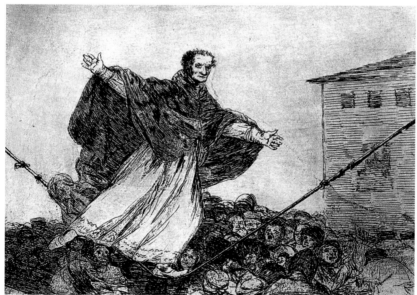

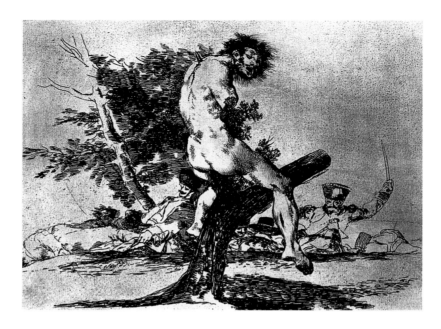

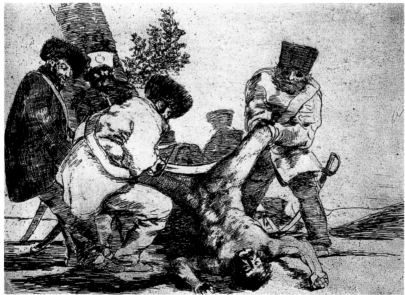

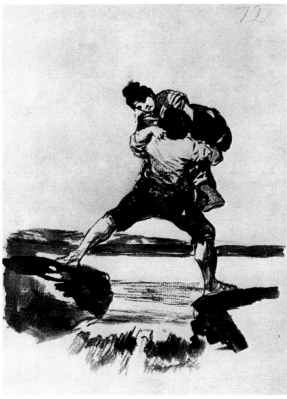

Woman Hitting Another Woman with a Shoe
(*Album F*), 1812–1823
Sepia wash, 20.5 x 14.1 cm
Rotterdam, Museum Boijmans van Beuningen

ILLUSTRATION RIGHT:
Peasant Carrying a Woman (*Album F*),
1812–1823
Sepia wash, 20.5 x 14.3 cm
New York, The Hispanic Society of America

As well as scenes of war and torture, Goya's
sketchbook includes a wealth of studies of
scenes from the daily lives of ordinary people.
We see dancing, drinking, a man helping a
woman over a stream.

and are created with supreme artistry. This is especially true of *The Third of May, 1808*. Only the victims are standing in the light and can be recognized as individuals, as people looking death squarely in the eye. Goya portrays the soldiers as anonymous. Each of the victims makes his own gesture – his hands clenched into fists, clasped in prayer, held in front of his face or flung wide apart as in images of the Crucified Christ. The soldiers, on the other hand, are rigid, one identical to the next. In case we should miss the allusion contained within the figure with his arms outstretched, Goya gives him stigmata on his open palms and lightens the area behind his head, almost like a halo. The technicalities of firing-squad procedure are of no interest to the artist. Otherwise he would have showed the prisoners tied up and would have positioned the riflemen further away, for no soldier wants to be looking into the face of his defenceless victim at the moment of execution. Goya has painted not a realistic picture but a religious one, in which he canonizes a people that has liberated itself from a tyrant. He thereby creates a national icon of Spanish resistance.

The motives behind these works were less heroic. Goya painted them in order to improve his standing with Ferdinand VII, the new tyrant, to keep his salary and to enable himself to continue living in Madrid. A certain practical opportunism was all part of Goya's character. Ferdinand graciously allowed him his salary but banished the two paintings to the storeroom. Championing the common people did not fit the image of an absolute monarch.

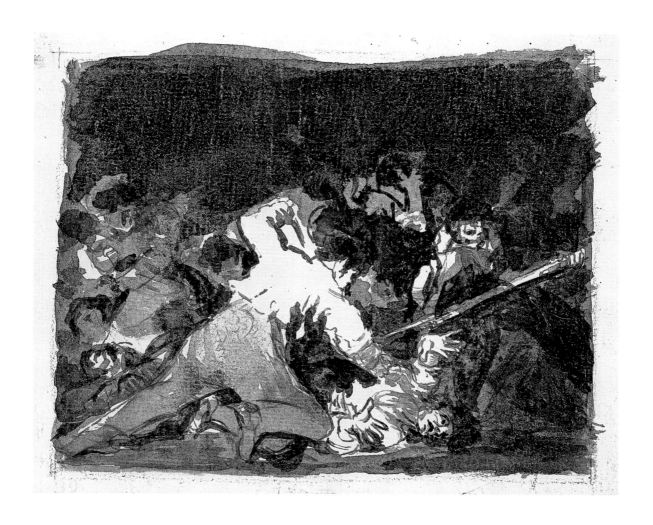

War Scene, 1810–1812
Brush and sepia wash, 15 x 19.5 cm
Madrid, Museo del Prado

A sombre scene, one of the designs that Goya did not
turn into an etching for *The Disasters of War*.

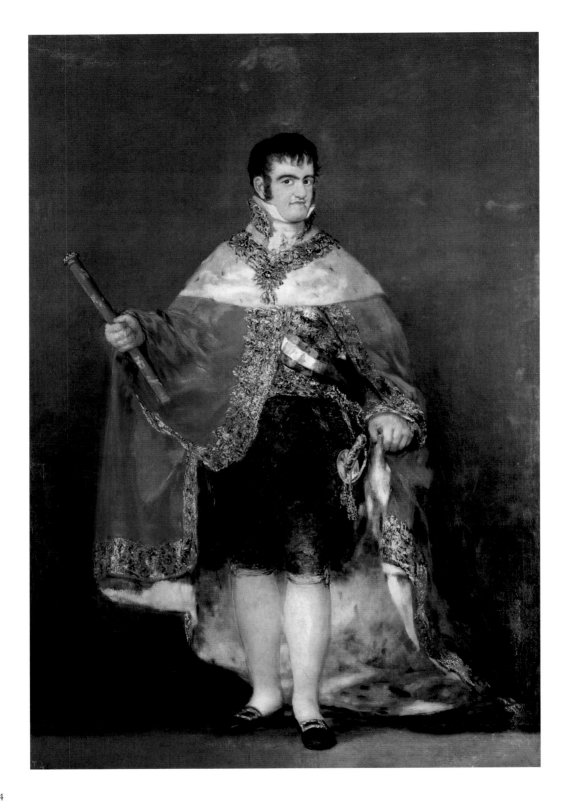

The Skies are Empty –
The Black Paintings

The war of liberation against the French was followed in Spain by a civil war, a period of chaos, oppression and resistance. On the one side King Ferdinand VII in association with the Church, and on the other those in support of a constitution. This constitution would give Spain's citizens greater rights and would weaken the alliance of Church and Crown. Gangs continued to terrorize the land. A period of menace and unrest.

Precisely when Goya painted *The Inquisition Tribunal* (ill. p. 67) and *The Burial of the Sardine* (ill. p. 66) is uncertain, but it must have been at the end of the war of liberation or in the years that followed. Although they do not speak directly of torture and death as his *Disasters of War* had done, they convey a palpable sense of danger. The orgiastic festival of the "Burial of the Sardine" was celebrated on the banks of the Manzanares, more or less where a similar crowd would spread out their picnics on the feast of St Isidore. The artist gives centre stage not to the larger crowd of merry-makers, but to a small group of masked figures dancing. In Goya's work, however, masks invariably serve to conceal deception, malice and demonic forces. The gloomy masked carnival signals danger.

The Inquisition Tribunal denounces the Church's reign of terror. Goya shows us an episode from an *auto de fé*, an "act of the faith". In a crowded courtroom, the accused confess to their heresy, are given their sentence and are "reconciled" with the Church. Should a heretic prove impenitent, however, he or she was expelled from the Church and handed over to the secular authorities to be burned alive. Although, when Goya painted his *Inquisition Tribunal*, such trials were no longer being held in public, they continued none the less to fuel the general sense of fear and powerlessness.

In 1819 Goya painted a picture of a quite different kind – a religious subject. It was commissioned by the order of the Escuelas Pías de San Antón, the "Pious Schools of St Anthony". The fathers of the order were committed to providing as good an education as possible. They sought to teach even the children of the very poor important life skills, for in this way, so the fathers believed, they would not lapse into sinful ways. Goya probably attended one of the "Pious Schools" as a child in Saragossa, and perhaps he was still grateful to his teachers, for he is said to have executed their commission for only a small fee. The resulting canvas portrays the founder of the order, *St Joseph of Calasanz*, who died in 1648 (ill. p. 68). Goya shows him taking his last Communion shortly before his death. The angels,

Self-portrait Aged 69, 1815
Oil on canvas, 51 x 46 cm
Madrid, Museo de la Real Academia
de San Fernando

ILLUSTRATION PAGE 64:
King Ferdinand VII with Royal Mantle, 1814
Oil on canvas, 212 x 146 cm
Madrid, Museo del Prado

With the French finally expelled, in 1814 Ferdinand VII returned from exile. The 30-year-old monarch proceeded to hound Spain's liberals, with whom Goya was closely affiliated. Anxious to keep his post and salary as Court Painter, Goya executed six portraits of the King, none of them commissioned.

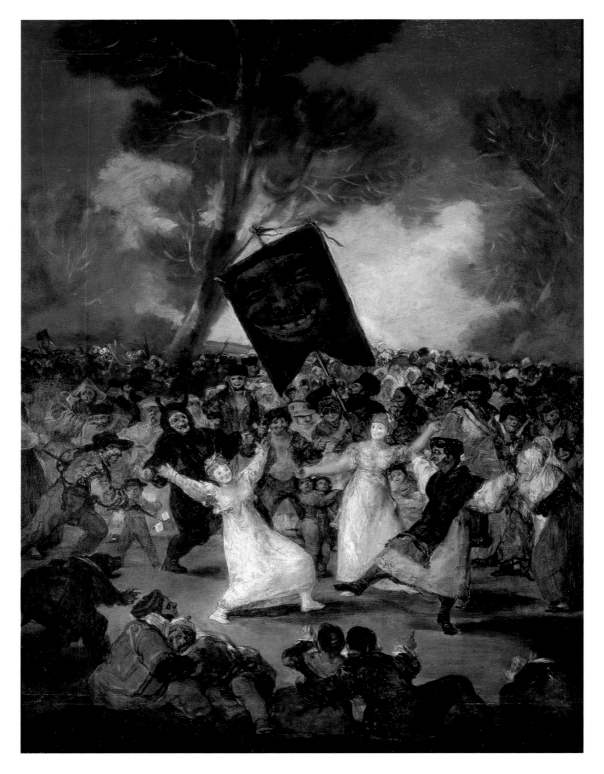

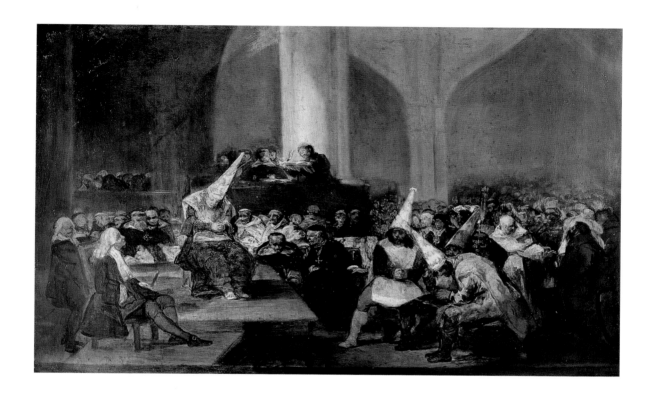

The Inquisition Tribunal, 1812–1819
Panel, 46 x 73 cm
Madrid, Museo de la Real Academia
de San Fernando

The Inquisition was introduced in Spain in the
15th century as a form of court run by the
Church and intended to protect the monarchy.
The last public *auto de fé* was staged in Madrid
in 1784. Nevertheless, under Ferdinand such a
"historical" scene could still be classed as anti-
clerical propaganda and could get the artist
into trouble.

ILLUSTRATION PAGE 66:
The Burial of the Sardine, 1812–1819
Panel, 82.5 x 52 cm
Madrid, Museo de la Real Academia
de San Fernando

The carnival celebrations in Madrid culminated
on Ash Wednesday in a procession with dancing
and masks. A heathen spring festival and a
parody of religious processions. Goya sensed
demonic forces behind masks and costumes.

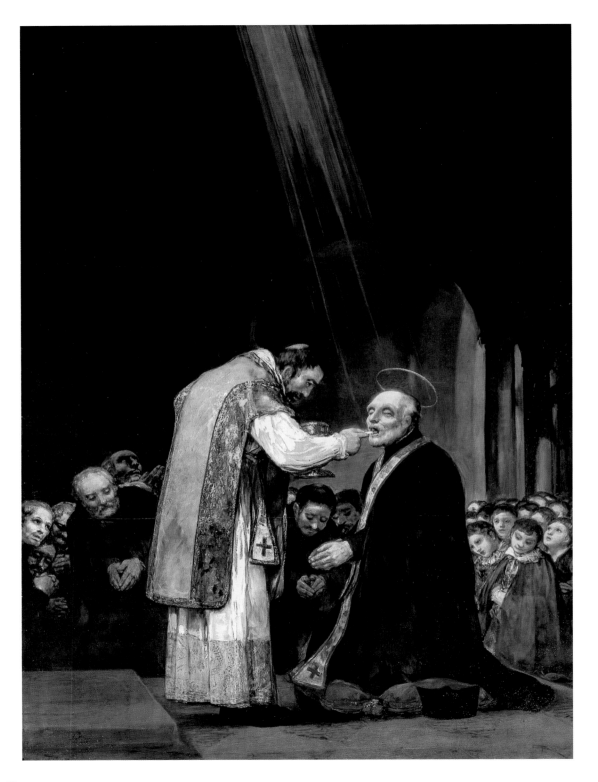

Christ and Mary, who are usually assembled, in religious painting, to receive the
soul of the devout man, are here absent. Descending from above is only a stream
of light, which might simply be falling through a high window. Calasanz himself
wears an extremely discreet halo. The painting is dominated not by the trad-
itionnal cast of heavenly beings, but by the kneeling saint and the priest who
is placing the host on his tongue – two people who are facing each other and
caught up entirely in what they are doing. Goya gives them something of a com-
mon outline, bringing them together into a single whole. An image of trust, one
of the few works by Goya which show that human relationships do not always
have to be ruled by deception and violence.

Goya also made a gift to the padres of a small painting of *Christ on the Mount
of Olives* (ill. p. 69). Why this scene in particular, in which the Son of God be-
lieves himself to have been abandoned by his Father? Did the artist want to con-
vey something about himself to the padres, to whom he evidently felt indebted?
Or simply say that he himself had lost the faith in God and humankind that he

A Miracle of St Anthony (detail), 1798
Fresco, dia. c. 550 cm
Madrid, San Antonio de la Florida

Angels do not fall out of the sky; people, however, need a balustrade. Goya uses it to emphasize that the earthly world extends as far as the edge of the cupola, which is usually claimed by the Church.

ILLUSTRATION PAGE 71:
A Miracle of St Anthony (view of the whole cupola), 1789
Fresco, dia. c. 550 cm
Madrid, San Antonio de la Florida

A church interior from happier times. Charles IV and María Luisa granted Goya a free hand in designing and executing the decorative scheme for the chapel of St Anthony. The artist gave the cupola a heaven entirely devoid of celestial beings. The figures we see instead are pious, happy and boisterous human beings. Not all of them are watching the miracle being performed by St Anthony, who is bringing a dead man back to life so that the latter can reveal who murdered him.

expresses in the figure of St Joseph, the founder of the order? He paints a man alone and wracked with doubt, as disciples and angels vanish into the darkness.

A comparison is invited here with frescos from happier times, works executed during the era in which Goya enjoyed the esteem of the King and Queen and painted their large family portrait. Minister of Justice at that time was the liberal-thinking Jovellanos, and it was he who secured Goya the commission to decorate the newly-built chapel of San Antonio de la Florida (ills. pp. 70/71). Since the chapel belonged to the palace, Goya's designs required the approval neither of the Academy nor of the Church hierarchy, and the royal couple gave the artist a free hand. It was the first time Goya had been granted the opportunity to decorate a church interior entirely on his own, and it is possible that he was even allowed to decide upon the programme himself. The main subject is the *Miracle of St Anthony*: St Anthony's father has been falsely accused of killing a man, and the saint brings the victim back to life so that he can name his true murderer. The miracle is supposed to have taken place in a courtroom in Lisbon in the 13th century. Goya locates the raising of the father at the bottom of the cupola, around

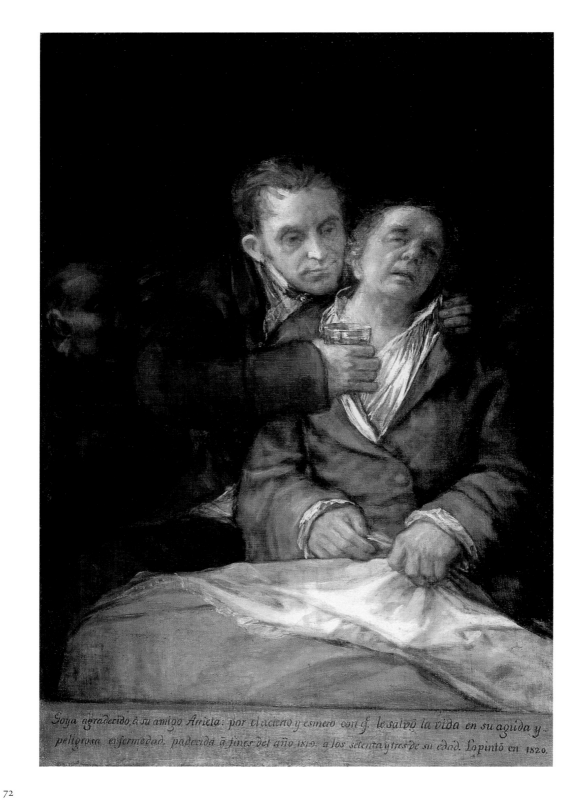

Goya agradecido, á su amigo Arrieta: por el acierto y esmero con q.e le salvó la vida en su aguda y peligrosa enfermedad, padecida á fines del año 1819, á los setenta y tres de su edad. Lo pintó en 1820.

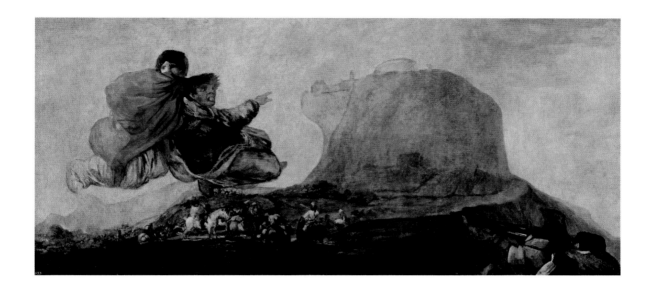

whose edge a painted balustrade serves to prevent the onlookers from falling down. They are a colourful crowd of men, women and children, clad in more or less contemporary dress. Rising above their heads is not the ceiling of a court-room, but a blue-grey sky. Had Goya followed tradition, he would have filled this sky with angels and saints, but he leaves it empty. He paints angels lower down in the chapel, some of them with clearly female bodies and wings which are worn so clumsily, they might be theatrical costumes. The reality formerly granted these divine figures by earlier artists, and indeed Goya himself, has gone. Goya deals even more radically with the saints and biblical figures who usually looked down benevolently upon humankind from above, and who Goya simply omits altogether. No one knows if he wanted to deny their existence. All that is apparent is that he no longer accepted the conventional way of representing such figures in contradiction of the laws of science.

Instead Goya paints a fair sky and, standing beneath it, people variously astonished and moved by the miracle or simply chatting amongst themselves. Two boys are climbing on the balustrade. The composition as a whole seems to serve as an affirmation of life and of ordinary people, of an existence entirely free from the dogmatic hierarchy of the Church. San Antonio de la Florida was consecrated in 1799; the two paintings for the fathers of the "Pious Schools" arose some 20 years later, in 1819. Goya's personal circumstances had by now changed.

In 1819 Goya bought a house on the outskirts of Madrid, above the Manzanares, near to where he had painted *The Meadow of St Isidore* (ill. pp. 14/15). He distanced himself from the gossip and prattle of city life, in which – being deaf – he was little able to participate anyway. One particular reason for his move may have been Leocadia Weiss, the young, married woman with whom Goya, the widower, maintained an "illicit relationship". She had moved in with him permanently in 1813, thinly disguised as his housekeeper. It seemed advisable to distance themselves from their neighbours, and the newly-acquired house stood in some 25 acres of grounds. It was called the Quinta del Sordo – "the country house of the deaf man".

Asmodea, 1820–1823
Oil on canvas, 123 x 265 cm
Madrid, Museo del Prado

Asmodi was a demon who lifted off the roofs of houses and revealed to his companion the licentious ways of their inhabitants. Probably an allusion to the artist's "illicit relationship" with Leocadia Weiss.

ILLUSTRATION PAGE 72:
Goya and his Doctor Arrieta, 1820
Oil on canvas, 117 x 79 cm
Minneapolis, Minnesota, Institute of Arts

In 1819 Goya fell seriously ill. After his recovery, he painted himself as a reluctant patient in the arms of his doctor, who is carefully but forcibly administering some medicine to him. A painting of rare intimacy, a testament to life-saving friendship.

Duel with Cudgels, 1820–1823
Oil on canvas, 123 x 266 cm
Madrid, Museo del Prado

Two men are battling each other with cudgels.
Both are standing up to their knees in sand, so
that neither can run away, and it remains un-
clear whether even the victor will be able to
extricate himself. There are no spectators in
sight. Bloody madness in a bleak landscape.

A way of flying (*Follies* or *Proverbs 13*), 1815–1820
Etching and aquatint, 24.5 x 35 cm

Flying witches, sorcerers, owls and bats appear
regularly throughout Goya's œuvre. When he is
able to work freely, his skies are filled not with
guardian angels but with demons wreaking
havoc. There is something eerie, too, about
men flying through the air on artificial wings.

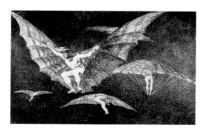

At the end of 1819 Goya fell seriously ill for the second time in his life. He
was restored to health by his friend Dr Arrieta. Goya thanked him with a double
portrait of doctor and patient, bearing the inscription: "Goya grateful to his
friend Arrieta: for the skill and care with which he saved his life during his short
and dangerous illness, endured at the end of 1819, at seventy-three years of age"
(ill. p. 72). After his first illness, which had left him deaf, Goya had embarked on
something new, namely paintings executed on his own initiative featuring motifs
that he was unable to explore in commissioned works. Now, having come close
to death a second time, he proceeded to cover two of the rooms in his new house
with pictures, 14 visionary paintings executed in oil on plaster, which were not
destined for public viewing. He shut himself up with them, seeking to withdraw
into solitude even in his œuvre.

It is conceivable that some of the figures and subjects treated in these paint-
ings were prompted by his current situation. One such is *Asmodea*, portraying
the evil spirit Asmodi from the Old Testament (ill. p. 73). The embodiment of
forbidden love, Asmodi was made popular in Spain by a novel of the 17th century,
in which he is portrayed as a demon who lifts off the roofs of Madrid and reveals
to his companion the illicit sexual relations conducted by its inhabitants. Goya
used the walls of his Quinta to show how he now saw the world and what threats
it held for him. It is a world empty and without meaning. Two men, sunk up to
their knees in sand, are battling each other with cudgels, and even the eventual
victor is unlikely to escape (ill. p. 74). And where is there to go anyway, in the
empty wilderness that surrounds them? A *Dog*, probably also sinking into quick-
sand, raises its head (ill. p. 75). In no other work does Goya offer such a radical
portrayal of empty space, one flying in the face of all artistic tradition. All that
can be seen of the dog is its head, occupying only about one percent of the pic-
torial plane. 99% of the composition remains devoid of all recognizable objects,
leaving aside the dark but otherwise unexplained slope at the bottom of the
painting. The dogs look upward, as if something might be expected from that
direction, but neither a person nor a saint reaches down to rescue him.

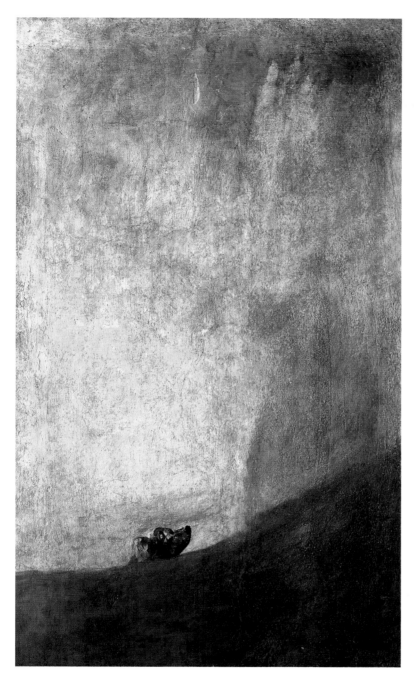

Caspar David Friedrich
The Monk by the Sea, 1808–1810
Oil on canvas, 110 x 171.5 cm
Berlin, Staatliche Museen zu Berlin –
Preußischer Kulturbesitz, Nationalgalerie

In Germany, a good ten years before Goya,
Caspar David Friedrich painted a picture with
a similar theme: the tiny figure of a man set
against a natural landscape divided into three
horizontal zones of colour. An extraordinary
picture for Friedrich, but the comparison reveals
Goya breaking even more decisively still with
the conventions of pictorial composition.

The Dog, 1820–1823
Oil on canvas, 134 x 80 cm
Madrid, Museo del Prado

The dog's head occupies barely one percent
of the pictorial plane. The rest is colour devoid
of objects. Never before had an artist exercised
such radical renunciation in order to portray
solitude.

Peter Paul Rubens
Saturn, 1636–1638
Oil on canvas, 180 x 87 cm
Madrid, Museo del Prado

The same subject, but from an era in which
art was indebted first and foremost to courtly
culture. Rubens does not portray Saturn as an
unkempt monster and, by means of stars and
clouds, translates his cannibalistic act to the
realm of myth.

In Germany some ten years earlier, in around 1809, Caspar David Friedrich
had executed a similarly radical painting, *The Monk by the Sea* (ill. p. 75). Fried-
rich, too, had reduced the world, albeit not to a single field of colour but to three
horizontal zones. Like the head of Goya's dog, Friedrich's monk occupies barely
one percent of the pictorial plane. In front of him sea and sky, overwhelmingly
vast. As a monk, the man on the shore may be trying to assimilate this sombre
panorama into his Christian world view, but the artist shows us nothing of this.
There is only water, sky and land, raising the inevitable doubt as to whether it is
not absurd for such an insubstantial human to seek for any sort of meaning in
the face of the nature confronting him, and before which he has nothing to say.
Goya goes one step further. In their use of zones of colour and their expression
of despair and hopelessness, however, both artists reach far beyond the artistic
conventions of their day.

The so-called "black paintings" in Goya's house were later removed from the
walls and transferred to canvas, and now hang in the Prado. A comparison of
their figures reveals that several share the same expressive facial characteristics:
staring eyes, revealing the whites at the top and the pupils below, and open or
eating mouths. It is thus that Goya portrays *Saturn*, who ate his children, and
who appears as a monster in human form devouring a child's body, dripping
with blood, clutched between his paws (ill. p. 77). Rubens had painted the same
motif in 1636 (ill. p. 76), but how harmless his Saturn seems in comparison to
Goya's! The body of Rubens' infant is still intact, no blood flows, everything is
painted smoothly and delicately, and the presence of stars and clouds relegates
the scene to the realm of mythology, far from the real world. Goya, on the other
hand, throws delicacy to the wind, works with a coarse brush, and depicts the
action with brutal realism and as if it were happening in the viewer's own sphere.
A vision of horror.

Similarly charged is the atmosphere in *The Pilgrimage of St Isidore* (ill. pp. 78/
79), a late pendant to *The Meadow of St Isidore* (ill. pp. 14/15), one of Goya's tap-
estry designs. The sunny afternoon of the earlier painting has now given way
to gloomy night with crowds of singing pilgrims, who pile up into a threatening
tower in the foreground. Again we see the whites of the eyes, indications of terror
or extreme intensity, and the wide-open mouths that appear with such frequency
in the œuvre of no other painter in the history of European art. Open mouths
were – and are still – considered taboo, both in society and, for a long time, in
art. Allegedly because they make the face ugly, but in truth more probably be-
cause the lips and mouth mark the start of the digestive tract – a part of the
human body that remains anonymous, a part that cannot contribute to the de-
sire for individuality as expressed, for example, in portraiture. A part, too, that
we share with many animals. To look down the throat is to remember that our
intellectual existence, which we consider our real one, is dependent upon organs
and instinctual drives that we cannot control and at whose mercy we lie.

If, in the paintings and etchings that he was free to design as he wished,
Goya repeatedly depicted open mouths, it was because he understood such "un-
civilized" elements as belonging to human existence. He also understood them
as a synonym for loss of control, however. He often shows them in conjunction
with staring eyes, at moments of extreme fear, as in the men facing execution in
The Third of May, 1808 (ill. p. 57), in a frenzy of greed as in *Saturn*, or in religious
ecstasy, as in the pilgrims who bellow out their songs into the night.

In his Quinta del Sordo Goya evokes a world which appears empty and
devoid of meaning. It is inhabited by people who – to borrow an image from

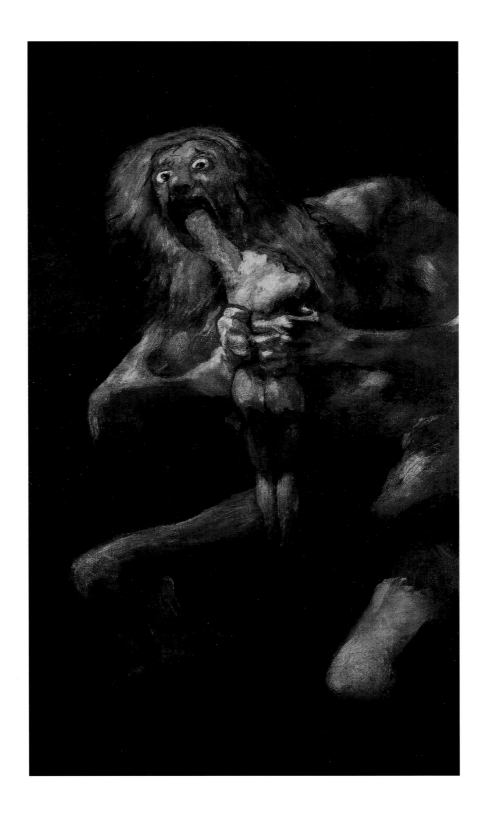

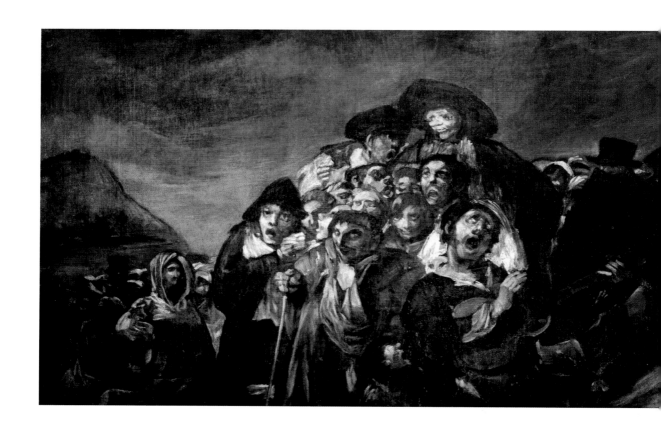

The Pilgrimage of St Isidore, 1820–1823
Oil on canvas, 140 x 438 cm
Madrid, Museo del Prado

Many years earlier, when he was still designing
tapestry cartoons, Goya had painted the feast
of St Isidore as a colourful popular gathering, a
cheerful scene intended for the bedroom of two
young princesses (ill. pp. 14/15). Now, in his ad-
vancing years and working only for himself, he
sees the pilgrimage to the saint's hermitage as
a gloomy nightmare.

La Leocadia, 1820–1823
Oil on canvas, 147 x 132 cm
Madrid, Museo del Prado

The woman dressed in mourning may represent Leocadia Weiss, who became Goya's partner after the death of his wife, Josefa.
She is leaning against a mound of earth with a grave rail on top. The artist offers no explanation for the scene. It is possible that Goya himself
is supposed to be lying in the grave, and that his *Black Paintings* are meant to be seen as messages from the hereafter.

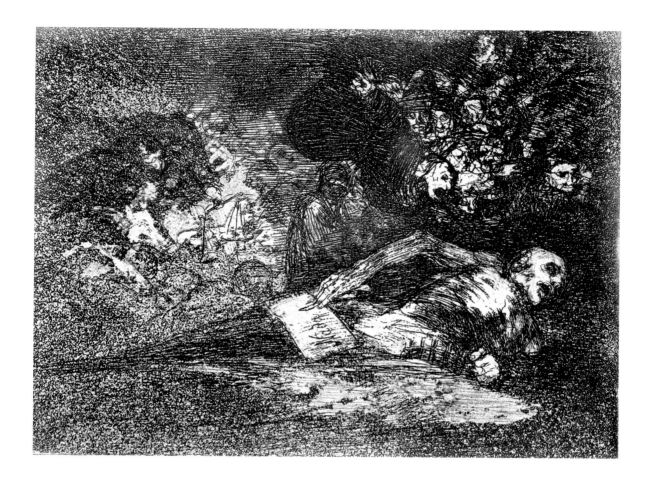

the Old Testament – might be said to have issued from a lump of clay that slipped out of God's hands before he was able to breathe life into it. Goya sets out no philosophical programme, but the dark paintings testify to the profound scepticism with which he viewed both the promises of salvation held out by the Church and the hopes for improved conditions in the present life held out by the Enlightenment. Probably not just scepticism, but also despair. Perhaps, too, fear of the flying witches and demons who inhabit the empty skies.

Beside the doorway, Goya painted a woman who may be his partner, Leocadia Weiss (ill. p. 80). Her eyes are pensive, her mouth closed, her pose relaxed. She is dressed in mourning and is leaning against a mound of earth surmounted by a low railing, of the kind found on Spanish graves. That a well-dressed woman should be draping herself over a mound of earth rather than mourning beside the railing seems unrealistic. But if we suppose that she wants to be physically close to the deceased, it makes sense. If this is Leocadia, then the person in the grave is the artist, her partner, and his black visions might therefore be understood as messages from the hereafter, where we are supposed to be so much closer to the truth than while still alive. It was an idea that Goya had already visualized in *The Disasters of War*. A corpse has clawed its way back out of the earth and points to a piece of paper, on which is written simply the word *Nada* – "Nothing".

Nothing. The event will tell (*The Disasters of War* 69), c. 1812–1820
Etching and aquatint, 15.5 x 20 cm

This etching plays on the hope that, after death, we shall finally learn the truth. Goya shows a corpse raising itself back out of the tomb. It points to a piece of paper, on which is written "*Nada*" – "Nothing".

A Love of Fear – The Bullfights

While Goya was surrounding himself with his visions of darkness, Spain was plunging ever deeper into civil war. In 1822 liberal politicians and army officers took Ferdinand prisoner. In 1823 he was freed by royalist French troops and initiated a fresh purge of all liberals. Thousands fled the country. A Prussian envoy wrote in June 1823 that the situation in Madrid was worse than in a newly captured city. For there, at least, "everything returns to order once the soldiers have satisfied their lust for booty; here, however, one is exposed day and night to the bayonets of the *soldateska*, who bear no trace of military breeding and know nothing but vengeance, pillage and theft."

Goya, in his Quinta del Sordo, also felt threatened. To prevent the authorities from being able to seize the house, he made it over to his 17-year-old grandson, Mariano. That was in the autumn of 1823. At the start of 1824 he went into hiding for three months at the home of a friend, and in June he emigrated. He wasn't running away; in order not to lose his status as Court Painter and the salary that went with it, he had lodged a formal request with the King for six months' leave of absence to allow him to take a cure for his failing health. He would live in Bordeaux until his death in 1828.

Upon his arrival there, a friend described the 78-year-old as "deaf, old, slow and weak and without knowing a word of French, and so content and eager to see the world!" He soon travelled on to Paris and spent a while there, although whether he made contact with other artists is unknown. He then settled in Bordeaux with Leocadia Weiss, her son and daughter, who may also have been Goya's daughter. He no longer accepted commissions, but made portraits of a number of friends, painted miniatures on ivory, tirelessly continued to fill his sketchbooks and experimented with lithography. Invented in 1796, this new printing process involved drawing directly onto the stone with an oily crayon and thus allowed the artist great spontaneity. Goya used the new technique for a series of four prints which have become known under the title *The Bulls of Bordeaux* (ills. pp. 86/87).

With this new technique, the almost 80-year-old artist returned to an old subject, that of bullfighting, which in the course of Goya's lifetime had been repeatedly banned and then re-instated by Spain's kings. Banned because, it was said, it was damaging to cattle breeding and the country's image abroad, and re-instated when the people needed to be mobilized, for example against

Self-portrait Aged 78, 1824
Pen and brown ink, 7 x 8.1 cm
Madrid, Museo del Prado

At the age of 78, Goya emigrated to France. After spending a few months in Paris, he settled in Bordeaux with Leocadia Weiss and her children.

ILLUSTRATION PAGE 82:
Picador Caught by the Bull, 1793
Oil on tinplate, 43 x 32 cm
London, British Rail Pension Trustee Co.

Goya was fascinated by bullfighting all his life and portrayed himself with a young bull in one of his early tapestry cartoons (ill. p. 9). In 1793 he submitted to the Royal Academy eight small paintings of scenes from the life of a bull chosen for the ring.

The Bravery of Martincho in the Ring of Saragossa (*Tauromaquia 18*), 1815–1816
Etching and aquatint, 24.5 x 35.5 cm

While working on *The Disasters of War*, Goya also etched 33 plates, which he offered for sale under the title of *Tauromaquia* (*The Art of Bullfighting*). Here he depicts a famous torero, seated on a chair and with his feet tied, preparing to deliver the bull a fatal thrust. A moment of extreme tension, which Goya makes palpable by abandoning the traditional rules of perspective.

ILLUSTRATION PAGE 85:
Portrait of Mariano Goya, 1815
Oil on canvas, 59 x 47 cm
Madrid, Collection Duque de Albuquerque

Goya was especially fond of his grandson Mariano and painted his portrait on several occasions. It was to Mariano that he gave the Quinta del Sordo, the house containing the *Black Paintings*.

the French. In 1812 the Spanish author León de Arroyal compared the "invention" of bullfighting with that of Attic tragedy. The Greeks had invented tragedy in order to cleanse the soul of fear and passion. Bullfighting had the same effect. But in the arena, the tragedy unfolded in real life and was not merely acted out on the stage.

Psychoanalysts are more likely to speak of the love of fear, of the desire to experience fear without being in real danger oneself. The love of fear stimulates the sense of being alive. The large number of works within Goya's œuvre that imagine menace, torture and death suggests that, for him, the love of fear served as an important creative force. As, on the other hand, did his passionate interest in women.

Goya was fascinated by bullfighting all his life. In one of the tapestry cartoons from the beginning of his career, he portrays himself almost tenderly with a young bull (ill. p. 9). When, in 1793, he submitted to the Royal Academy a set of small pictures of subjects he had chosen himself, eight of them were devoted to scenes from the life of a bull destined for the corrida – from being rounded up in the fields to the moment in which its dead body is dragged out of the ring. In 1815 and 1816, while he was working on *The Disasters of War*, he etched a series of 33 plates which he published under the title of *Tauromaquia* (*The Art of Bullfighting*). He was hoping for large-volume sales, but failed to achieve them, for he was offering the public something quite unlike the simple compositions it was used to seeing.

Very different to the norm, for example, is his presentation of the famous torero Martincho, seated on a chair with his feet tied, ready to deliver a fatal blow to the bull before him (ill. p. 84). For this moment of supreme courage and

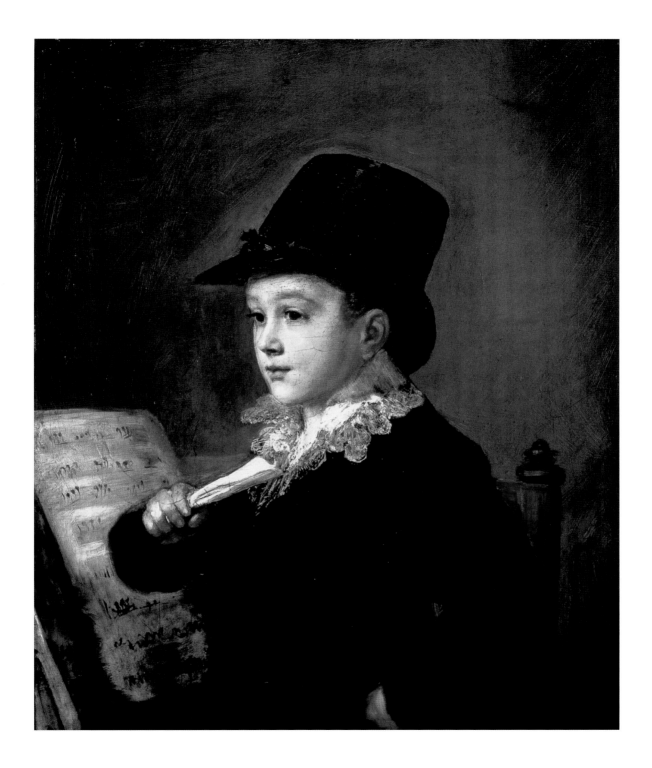

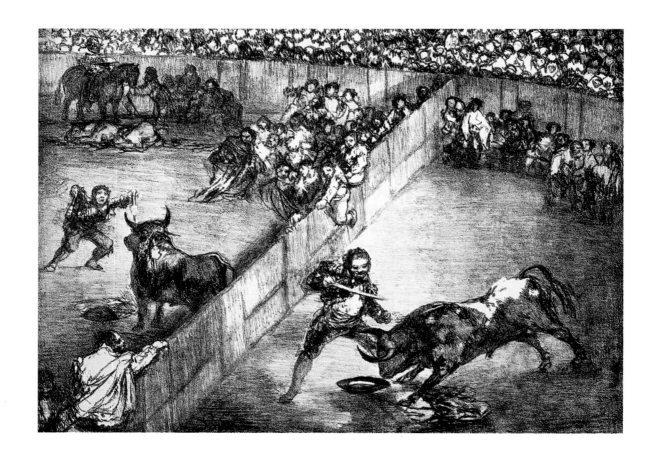

The Divided Arena (*The Bulls of Bordeaux*), 1825
Lithograph, 30 x 42.5 cm
Madrid, Biblioteca nacional

At the end of his life, three years before his death, Goya
once again returned to the subject of bullfighting, using
the new technique of lithography to produce the four
prints in the series *The Bulls of Bordeaux*.

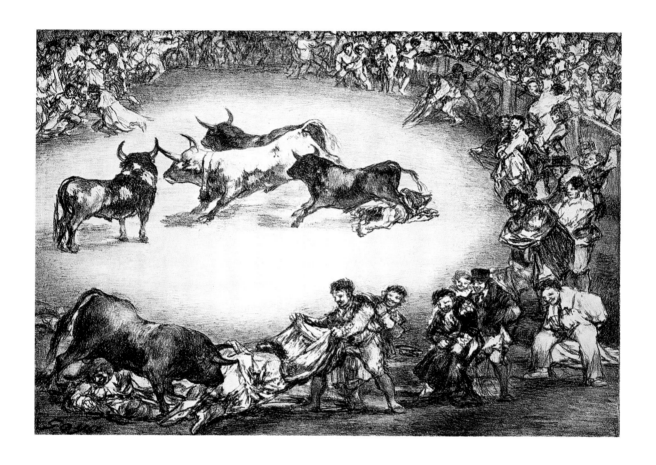

Spanish Entertainment (*The Bulls of Bordeaux*), 1825
Lithograph, 30 x 41 cm
Madrid, Biblioteca nacional

As in his early paintings, and unlike in his *Tauromaquia*,
Goya takes a step back from the events in the ring. His
focus now falls not on the battle to the death that had
earlier fascinated him and inspired him to new com-
positional solutions, but on the bullfight as popular
entertainment. Perhaps the emigré was also inspired
by reminiscences of life in Spain.

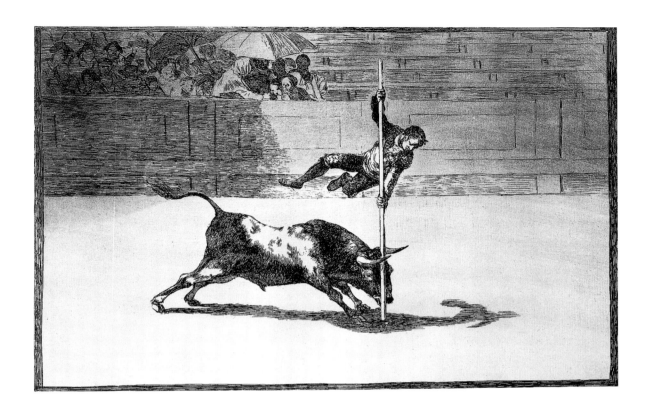

The Speed and Daring of Juanito Apiñani in the Ring of Madrid (*Tauromaquia 20*), 1815–1816
Etching and aquatint, 24.5 x 35.5 cm

In the *Tauromaquia*, unlike in his paintings, Goya allows the ring and the spectators to almost disappear and concentrates entirely on the fight between the bull and the man.

supreme danger, Goya abandons the laws of perspective, portraying the spectators as if seen from a higher viewpoint than the torero and bull in the ring below them. He reduces the floor of the arena to two planes, of which the rear, light-coloured plane appears to rise up like a vertical wall and thereby defies logical interpretation by the eye. The stand is reduced to a wedge; if we mentally take it away, it becomes clear that this dark element is precisely what lends the image its dynamism. This is not the visual record of a bullfight, but a compositional solution of a new type.

Goya's version of a disaster that occurred during a bullfight in Madrid in 1801 also infringed the rules of art (ill. p. 89). A bull leapt over the wooden wall separating the stands from the arena and killed a mayor and injured a number of spectators. Goya may even have witnessed the unfortunate event, but when he came to draw the incident, 15 years had elapsed. Although exuding the immediacy and directness of a very recent event, the composition is in fact entirely artificial. In the left half of the picture Goya draws only empty seating; the action is all concentrated on the right. A number of spectators are nevertheless flinging themselves from right to left. Goya transforms the static harmony into a dynamic one, in a fashion that no one before him had ever attempted with such disregard for visual convention. The powerful bull with the mayor on its horns stands frozen on the edge of the composition. Goya erects a monument in his honour: the motionless animal above the terrified spectators fleeing the scene.

In the etchings of the *Tauromaquia*, Goya brings bull and torero right into the foreground. In *The Bulls of Bordeaux*, they remain at a distance. The need

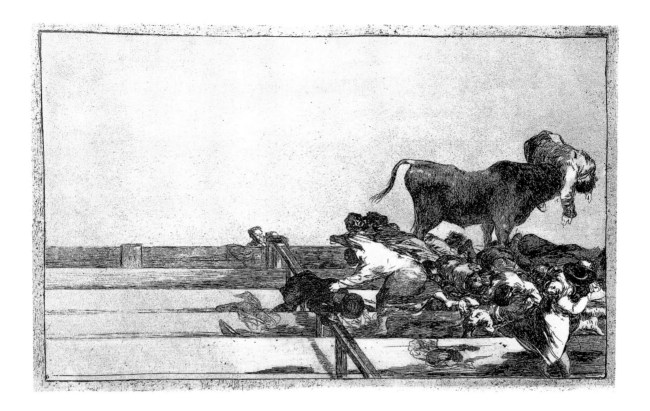

to satisfy his love of fear has diminished; he now enjoys sitting or standing amongst the crowd, focuses on the entertainment rather than the danger, has lost his former scepticism towards people. He also laughs at himself or at old men in general, who swing and dance as if still full of youth (ills. p. 90).

Amongst the loveliest figures of his last years is the so-called *Milkmaid of Bordeaux*, with her mysterious expression (ill. p. 91). The rounded contours of her body imply tenderness or devotion, and the size of the figure suggests that the artist was seeking to achieve a monumental effect. A woman of the common people as a worldly Mary? It is an association reinforced by Goya's use of blue. Since the Middle Ages, artists had traditionally robed the Virgin in blue, and Goya had portrayed her in a similar fashion in his early church frescos in Saragossa. Blue radiates a positive aura; no wonder the colour had been absent from Goya's palette for so long. Only here, at the end of his life, does he return to it.

Goya died on 16 April 1828, at the age of 82 – a patriot in exile. It would be several decades before the impact of his œuvre began to make itself felt in Europe. An œuvre which questioned conventional notions of beauty in art and thereby set new standards. An œuvre which rendered visible humankind's darkest fears and bestial impulses. Like no other artist of his day, Goya broadened our image of man. The Romantics of the 19th century were the first to sense this, and the murderous wars of the 20th century provided terrifying confirmation of his vision of humankind.

Unfortunate Events in the Front Seats of the Ring of Madrid (*Tauromaquia 21*), 1815–1816
Etching and aquatint, 24.5 x 35.5 cm

A bull has leapt over the barrier and killed and injured a number of spectators. Goya leaves the left half of the picture empty, infringing the rules of compositional harmony. A number of spectators are nevertheless flinging themselves from right to left: out of the static balance, Goya develops a dynamic one.

Old Man on a Swing (*Album H*), 1824–1828
Black chalk, 19 x 15.1 cm
New York, Hispanic Society

In his last sketchbook, Goya pokes fun at old
men who act as if they were still young. He
occasionally takes a look at himself, too,
from an ironic distance.

Phantom Dancing with Castanets (*Album H*),
1824–1828
Black chalk, 18.9 x 13.9 cm
Madrid, Museo del Prado

The phantom is an old man swaying
and dancing in his nightshirt.

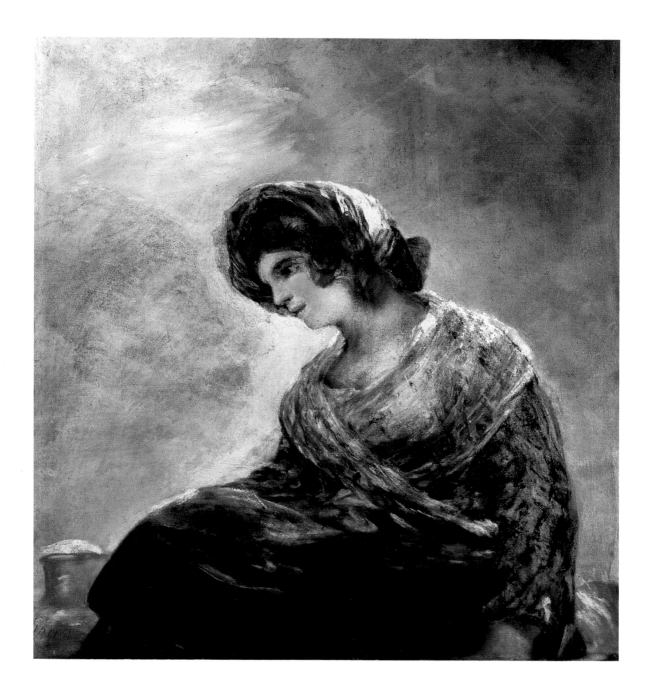

The Milkmaid of Bordeaux, 1825–1827
Oil on canvas, 74 x 68 cm
Madrid, Museo del Prado

One of Goya's last female figures, a painting in changing shades of blue.
Blue had served as the colour of the Virgin's mantle in art since the Middle
Ages. For Goya, blue radiated a positive aura. He rarely used it.

Life and Work

ILLUSTRATION PAGE 93:
The Duchess of Alba, 1795
Oil on canvas, 194 x 130 cm
Madrid, Collection of the Duchess of Alba

ILLUSTRATION BOTTOM:
Josefa Bayeu, 1805
Black chalk, 11.1 x 8.1 cm
Madrid, Collection Marques de Casa Torres

ILLUSTRATION BELOW:
The Hermitage of St Isidore, 1788
Oil sketch on canvas, 42 x 44 cm
Madrid, Museo del Prado

1746 Francisco Goya is born in the village of Fuendetodos near Saragossa. Childhood and first instruction in painting in Saragossa. Twice during the 1760s he enters competitions held by the Royal Academy of Fine Arts of San Fernando in Madrid, on both occasions failing to win a prize.

1770 Trip to Italy: honourable mention in a competition held by the Academy in Parma.

1771 Returns to Saragossa; first commissions for the Church.

1773 Marries Josefa Bayeu, the sister of the successful painter Francisco Bayeu.

Continues to work in Saragossa, executing frescos for the Charterhouse of Aula Dei.

1774 Goya is commissioned by the Royal Tapestry Factory of Santa Bárbara to produce designs (cartoons) for tapestries. He moves to Madrid.

1775 Goya begins a series of tapestry cartoons (he will produce 62 over the following 17 years) depicting scenes of popular and rustic pastimes. His designs, which are to be woven into tapestries for the royal palaces, please the future King Charles IV and his wife, María Luisa. Start of Goya's professional and social ascent.

1780 He is unanimously elected a member of the Royal Academy of Fine Arts of San Fernando.

1783 *The Count of Floridablanca*, a royal minister, commissions Goya to paint his portrait. Other members of the aristocracy, such as *Don Luis de Bourbon* and the Duke and Duchess of Osuna, follow suit. Goya finds himself in demand as a portraitist.

1784 Birth of his son Francisco Javier, the only one of his children to survive him.

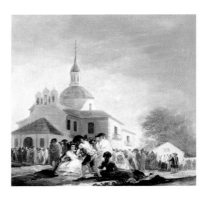

1786 Appointed Painter to the King (*Pintor del Rey*) with an annual salary of 15,000 *reales*.

1788 Following the death of Charles III, Charles IV becomes King of Spain.

1789 Goya becomes Court Painter (*Pintor de Cámara*). Revolution breaks out in France, calling for liberty, equality and fraternity: the aristocracy is abolished.

1792 Last tapestry cartoons. Goya visits Andalusia, falls seriously ill and goes deaf. France declares itself a republic and in Madrid, Manuel Godoy, the Queen's lover, becomes prime minister.

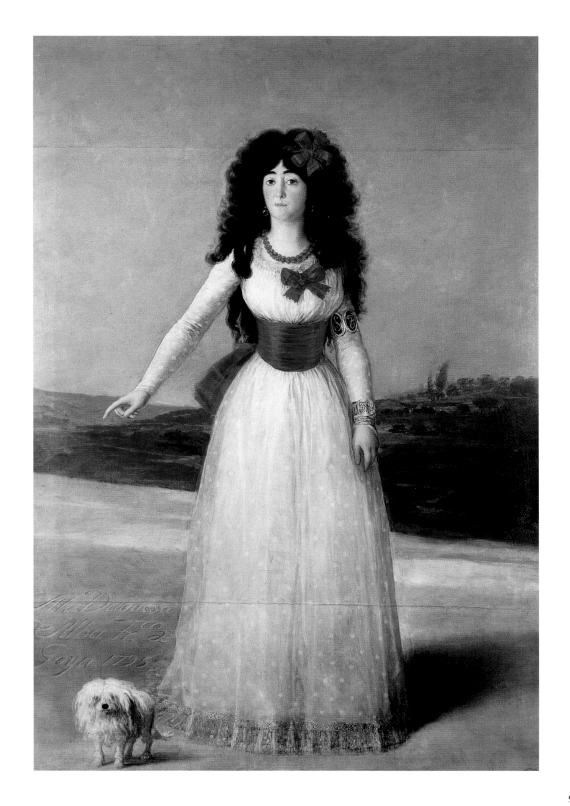

1793 Goya returns to Madrid and resumes work. In Paris, Louis XVI and Marie-Antoinette are executed. France declares war on Spain.

1795 Goya is appointed Director of the Royal Academy. Portrait of *The Duchess of Alba* and of the Duke of Alba, who dies the following year. Godoy concludes an inglorious peace with France. Napoleon Bonaparte becomes commander of the French army.

1796/97 Goya visits Andalusia, spending several months with the widowed Duchess of Alba at her country estate.

He paints her Portrait in black, fills the pages of his *Sanlúcar Album* with sketches and starts work on the *Caprichos*. Spain allies herself with France against England.

1798 Goya paints the portrait of the minister *Jovellanos* and frescos for the chapel of San Antonio de la Florida.

1799 Publication of *Los Caprichos*, a series of 80 etchings. Goya becomes First Court Painter (*Primer Pintor de Cámara*) with an annual salary of 50,000 *reales*. In France, Napoleon seizes power.

1800 Following numerous preliminary studies, Goya paints the group portrait of *The Family of Charles IV.*

1802 Sudden and mysterious death of the Duchess of Alba.

1804 Napoleon crowns himself Emperor of France.

1806 Birth of Goya's grandson Mariano.

1807 Despite a pact of neutrality, the French army invades Spain.

1808 Godoy is toppled, Charles IV abdicates. His successor, Ferdinand VII, is forced into exile. In Madrid on 2 May, a popular uprising against the French is brutally quashed. Start of the Spanish war of independence against the occupying forces; it will last five years.

1810 Goya starts work on a series of etchings entitled *The Disasters of War* and paints the *Portrait of Joseph Bonaparte*, whom Napoleon has installed on the Spanish throne.

1812 Death of Goya's wife Josefa, followed by an inventory and division of his goods with his son Javier. One

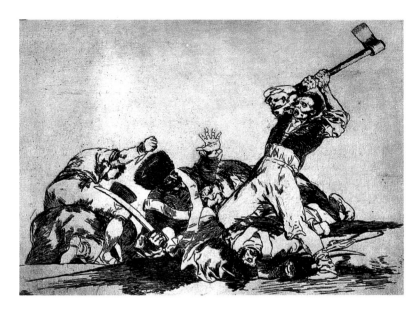

ILLUSTRATION LEFT:
The same (*The Disasters of War 3*), c. 1810–1815
Etching and wash, 16 x 22.1 cm

ILLUSTRATION BOTTOM:
Who Can Think of It? (*Album C*), 1814–1823
Sepia wash and Indian ink, 20.5 x 14.2 cm
Madrid, Museo del Prado

year later, Leocadia Weiss and her two children move in with him.

1814 King Ferdinand VII returns to Spain following the defeat and abdication of Napoleon. Absolutist crackdown. Persecution of liberals. Goya executes the history paintings *The Second of May* and *The Third of May, 1808*. He retains his title and salary, but has to appear in front of the

Inquisition to defend the charges of obscenity levelled at his *Naked Maja*, which together with *Maja Clothed* formed part of Godoy's collection. Both works are impounded.

1816 Publication of *Tauromaquia* (*The Art of Bullfighting*), a series of 33 aquatints.

1819 Goya purchases the Quinta del Sordo ("country house of the deaf man") for 60,000 *reales*. He falls seriously ill.

1820/23 He decorates the walls of two rooms of his house with his so-called "black paintings". Drawings and etchings. Spanish reformers force the King to accept a liberal constitution, but with the help of the French they are defeated and viciously persecuted. Goya fears repressive measures and makes his house over to his grandson, Mariano.

1824 Goya goes into hiding, but then profits from an amnesty and is granted royal permission to travel to France to take a cure. He goes into exile with

Leocadia Weiss, first visiting Paris, then settling in Bordeaux, where many of his liberal Spanish friends are living.

1825 Goya publishes the lithographs *The Bulls of Bordeaux*.

1826 He returns briefly to Madrid in order to file his request to retire as Court Painter. The King graciously awards him an annual pension of 50,000 *reales*.

1827 Second visit to Madrid. After his return to France, Goya paints *The Milkmaid of Bordeaux*.

1828 On 16 April Goya dies in Bordeaux. In 1901 his remains are taken back to Madrid and in 1929 his ashes buried in the chapel of San Antonio de la Florida, beneath the frescos executed in 1798 by the artist himself.

Selected Bibliography

Chastenet, Jacques: *La vie quotidienne en Espagne au temps de Goya*. Paris 1966

Feuchtwanger, Lion: *This is the Hour. A novel about Goya*. New Haven 1951

Gassier, Pierre and Juliet Wilson: *Francisco Goya, The Life and Complete Work of Francisco Goya*. New York and London 1971

Goya, Francisco de: *Cartas a Martin Zapater*. Madrid 1982

Gudiol, José: *Goya*. 4 vols. New York 1971

Held, Jutta: *Goya*. Reinbek 1980

Hofmann, Werner: *Goya – Das Zeitalter der Revolutionen*. Hamburg/Munich 1980

Klingender, F. D: *Goya in the Democratic Tradition*. London 1948

Licht, Fred: *Goya*. New York and London 2001

Matilla, Jose Manuel and Jose Miguel Medrano: *El Libro de la Tauromaquia de Francisco de Goya*. Museo Nacional del Prado, Madrid 2001

Museo del Prado, Madrid: *Goya y la Imagen de la Mujer* (exhibition catalogue). Madrid 2002

Nordström, Folke: *Goya, Saturn and Melancholy*. Stockholm 1962

Pérez Sánchez, Alfonso and Julián Gállego: *Goya, The Complete Etchings and Lithographs*, Munich and New York 1995

Pérez Sánchez, Alfonso and Eleanor Sayre: *Goya and the Spirit of Enlightenment* (exhibition catalogue). Boston 1989

Tomlinson, Janis: *Francisco Goya: The Tapestry Cartoons and Early Career at the Court of Madrid*. New York 1989

Tomlinson, Janis: *Goya in the Twilight of Enlightenment*. New Haven and London 1992

Tomlinson, Janis (ed.): *Goya, Images of Women* (exhibition catalogue). National Gallery of Art, Washington D. C. 2002

Williams, Gwyn: *Goya and the Impossible Revolution*. New York 1976

Photo Credits